Useless Info

Jim Watson began his career in tattooing in the windy city of Chicago in the late 1960's. Much of Jim's time while in Chicago was spent in Cliff Raven's tattoo shop, on Chicago's North side. While there, he focused all of his energy on getting tattooed and soaking up as much tattoo knowledge and technique as possible. Then, in 1971, Jim opened up his own tattoo shop in the Capital Hill area of Denver, Colorado. After 4 successful years in Denver, Jim moved and settled in Phoenix, Arizona where he continued to tattoo. Today Jim owns and operates Artistic Skin Design located at 664 West Camelback Rd. Although Jim no longer works out of the shop on a day-to-day basis, he still has been known to perform the occasional tattoo for friends, family, and by special appointments.

After decades of tattooing thousands of people, Jim recognized the difficulty for aspiring tattoo artists to get started in the world of tattooing. Along with the help of his good friend John Fox, Superior Tattoo Equipment® opened in 1991 with the intent of giving professional artists, as well as aspiring artists, a place where they could get the highest quality tattoo equipment at the best prices in the industry. The business was started in a small room in the back of Jim's tattoo shop, and has grown every year since it's inception, and has now become the "Number One" tattoo equipment supplier in the US (According to "International Tattoo Art Magazine®"). Still located in Arizona, now at 6501 North Back Canyon Highway, Superior Tattoo Equipment® continues to serve the tattoo community by offering the widest variety of tattoo equipment for the best prices, while shipping supplies to tattoo artists worldwide!

In recent years, the "tattoo artist sketchbook" has become a valuable resource for great tattoo ideas and designs. Although Jim Watson's tattoo style is normally recognized for being bright and colorful, these sketches show the reader the drawing technique and sketching process of a tattoo artist. The following pages contain valuable reference for tattoo artists, and craftsmen alike, and is a great source for easy to copy, and easy to perform, tattoo designs. This collection will help everyone, from new artists to journeymen, as well as their clients, to select (and, if needed, modify) the tattoo that they want. Enjoy the reference material and please feel free to offer suggestions for our next sketchbook.

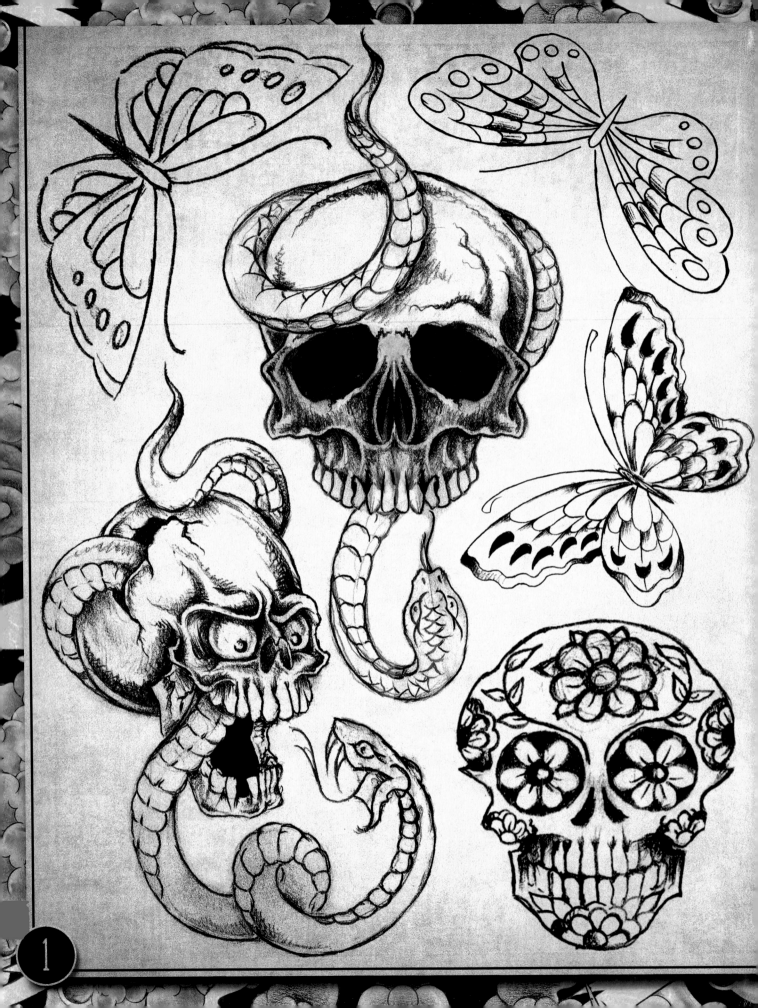

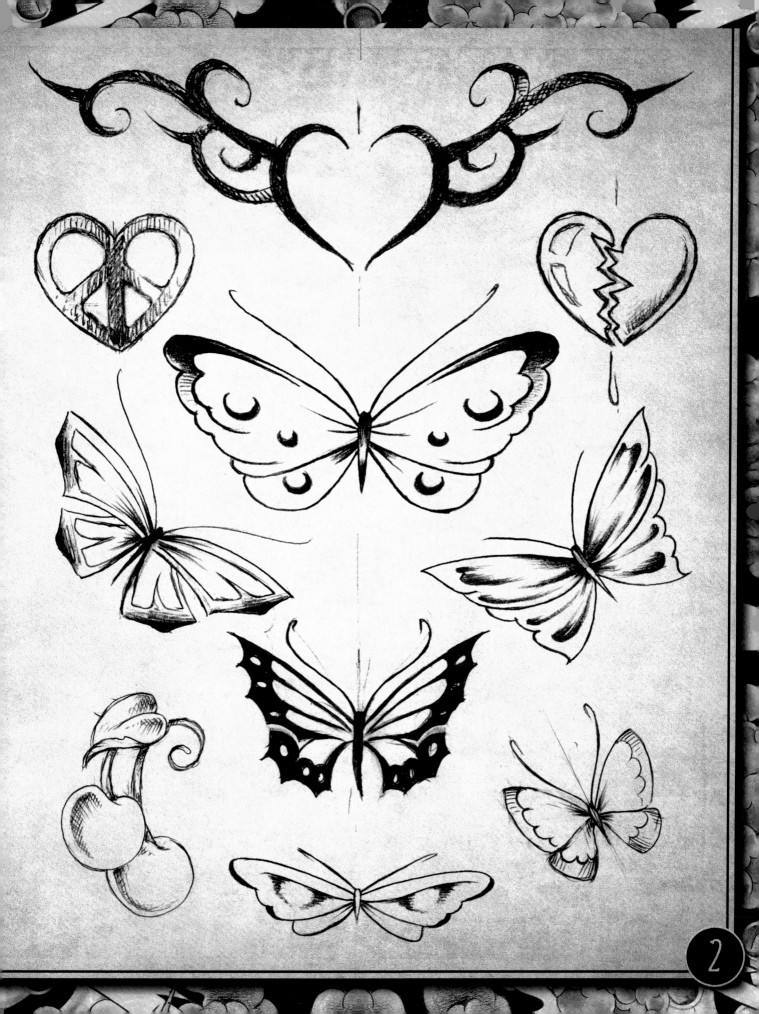

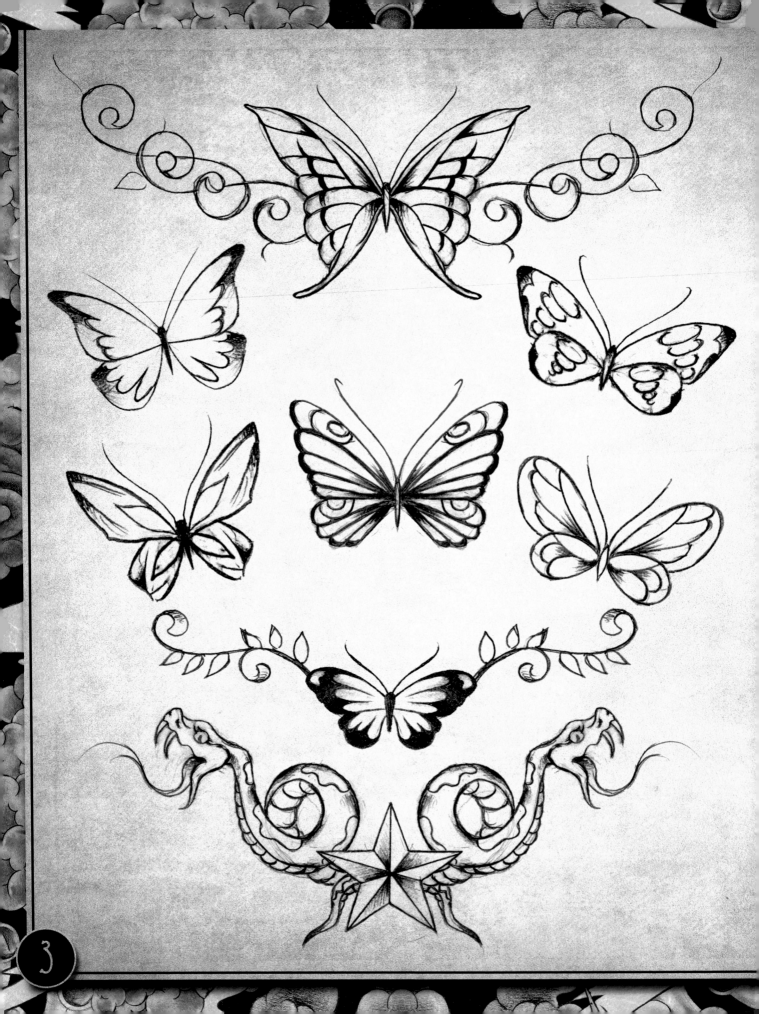

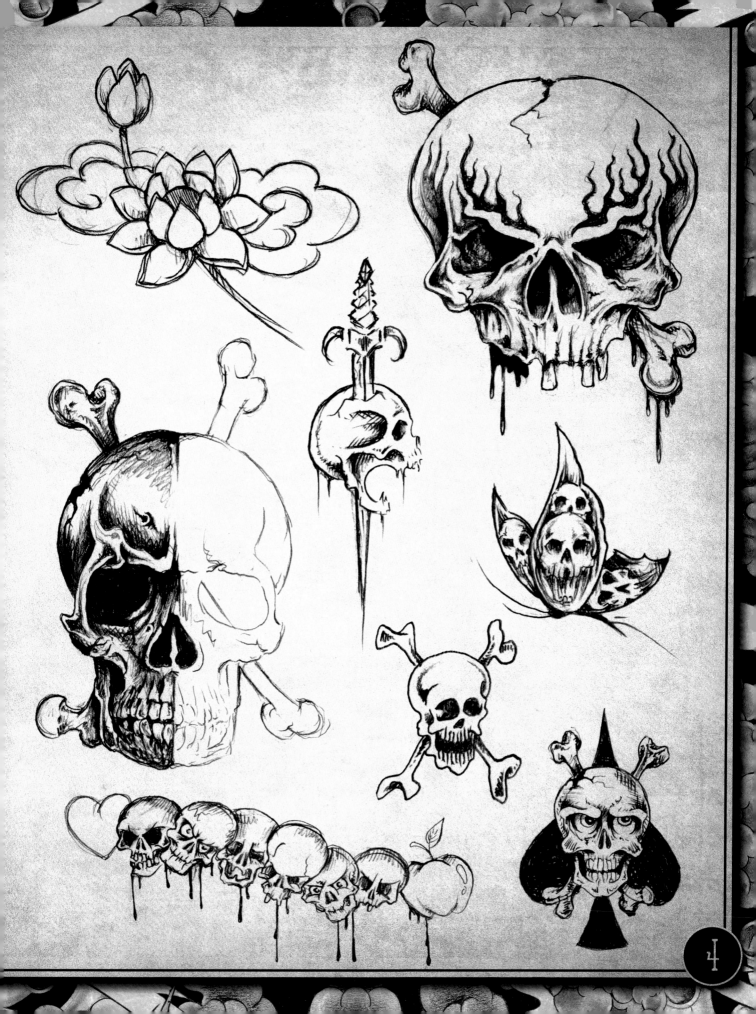

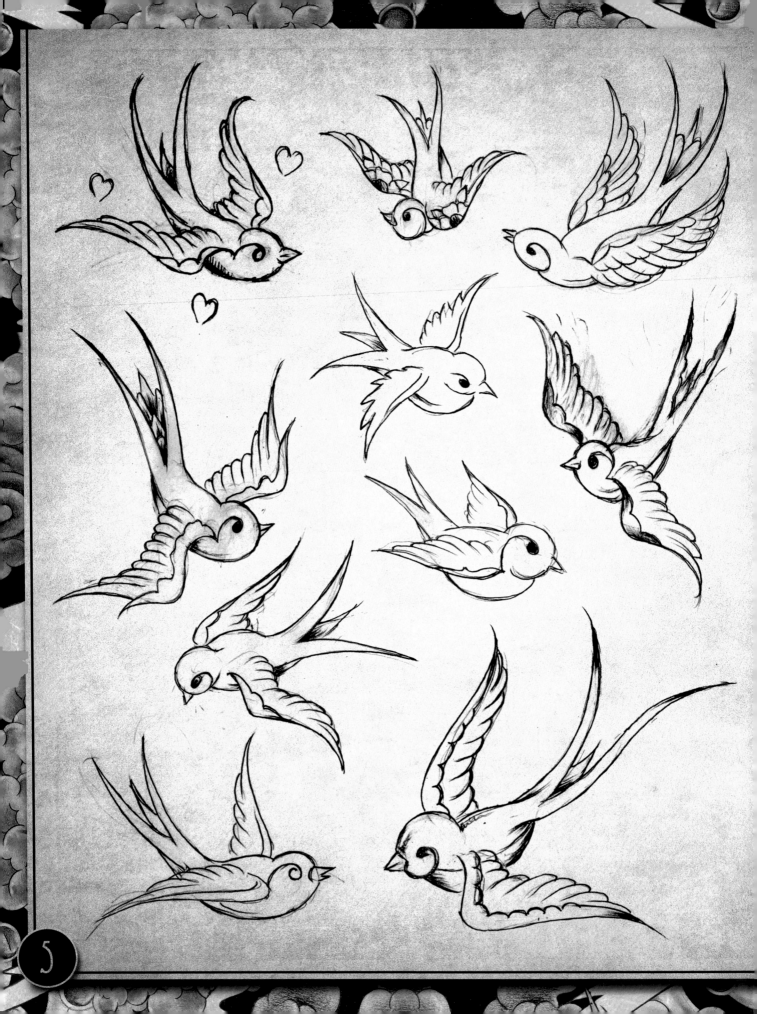

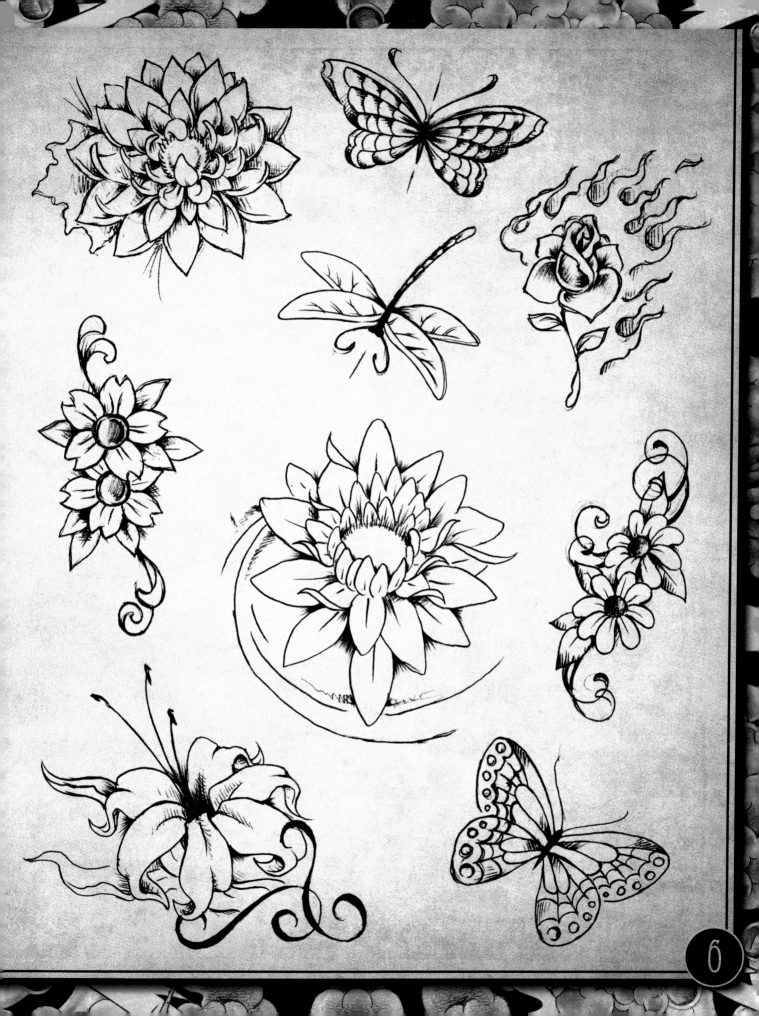

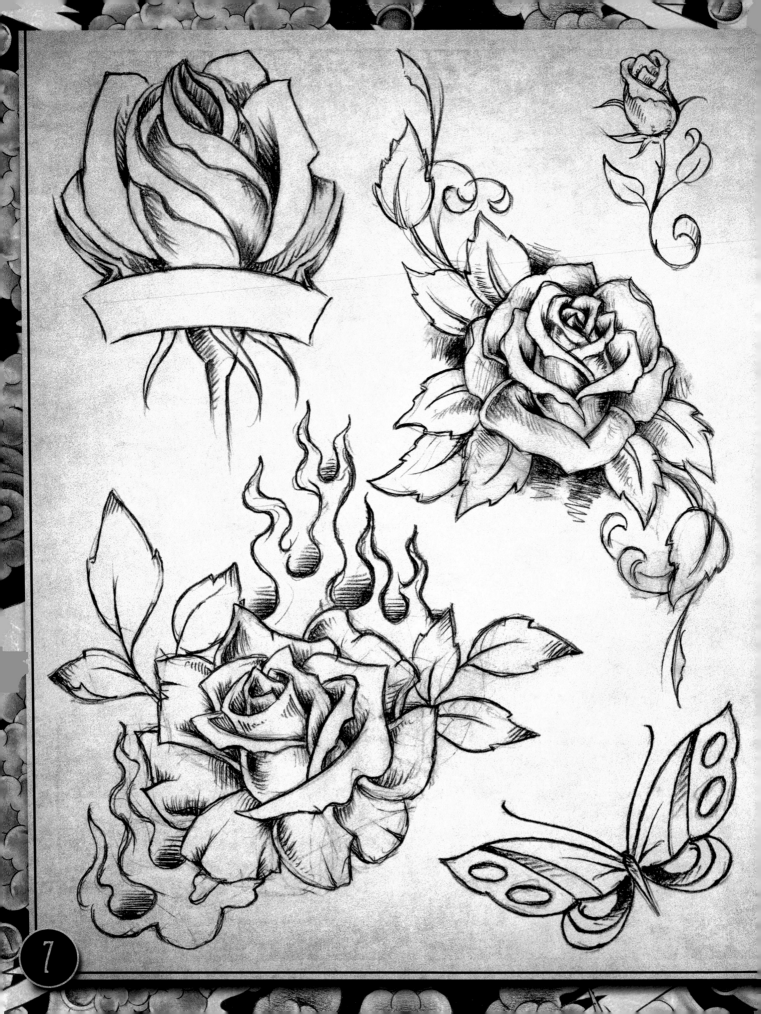

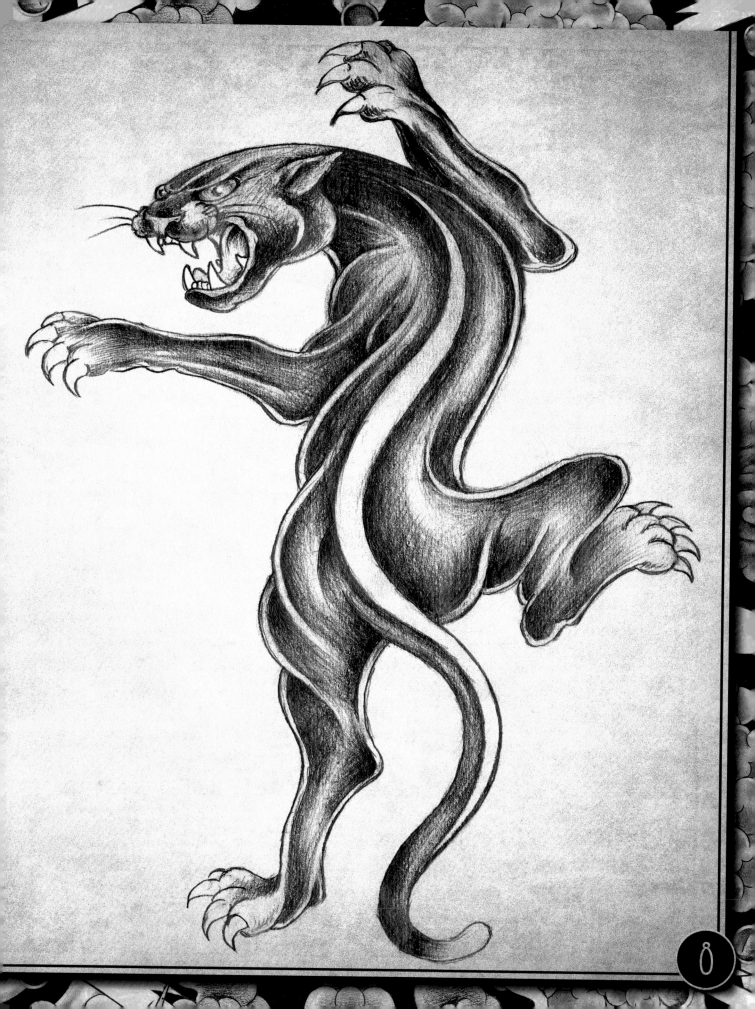

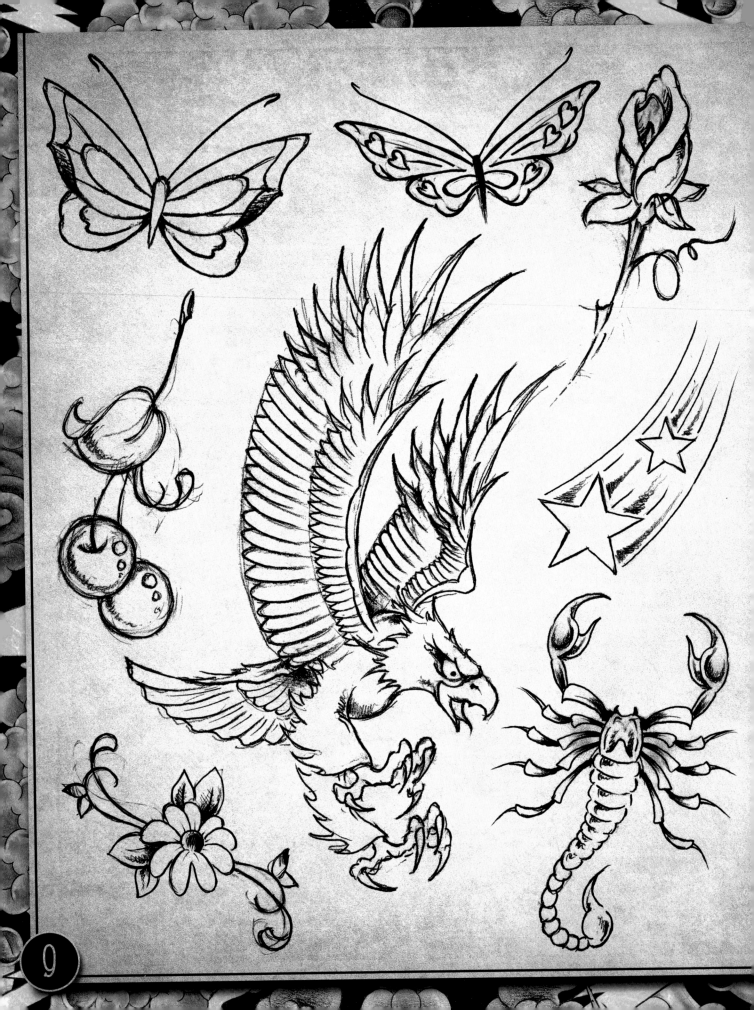

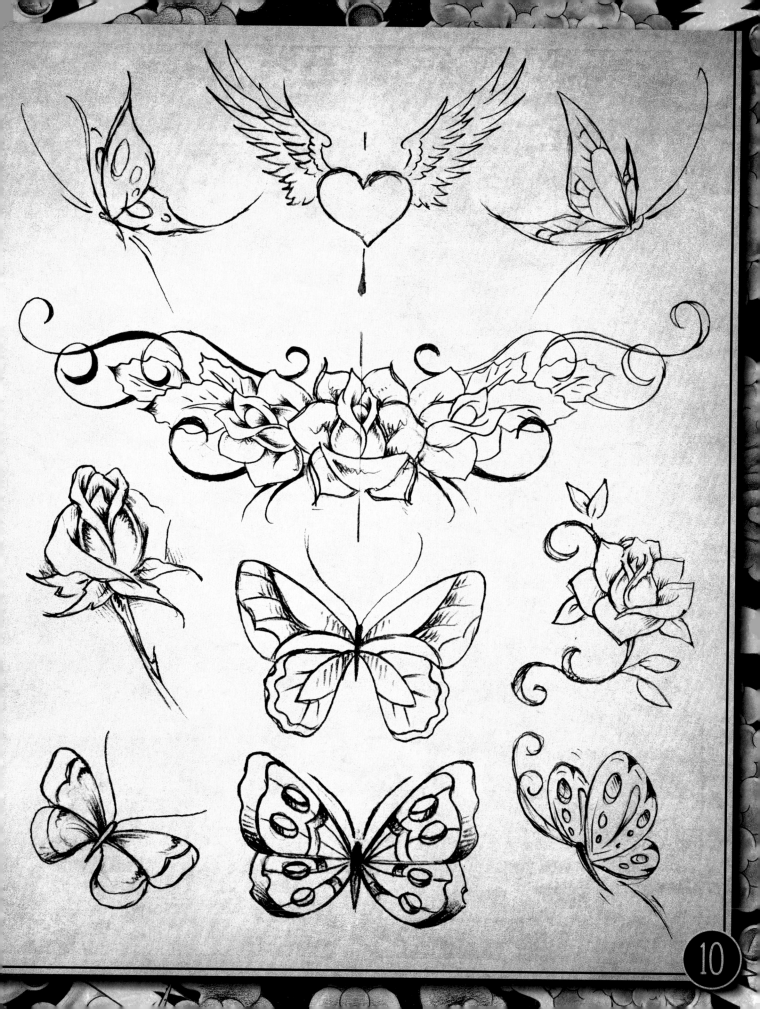

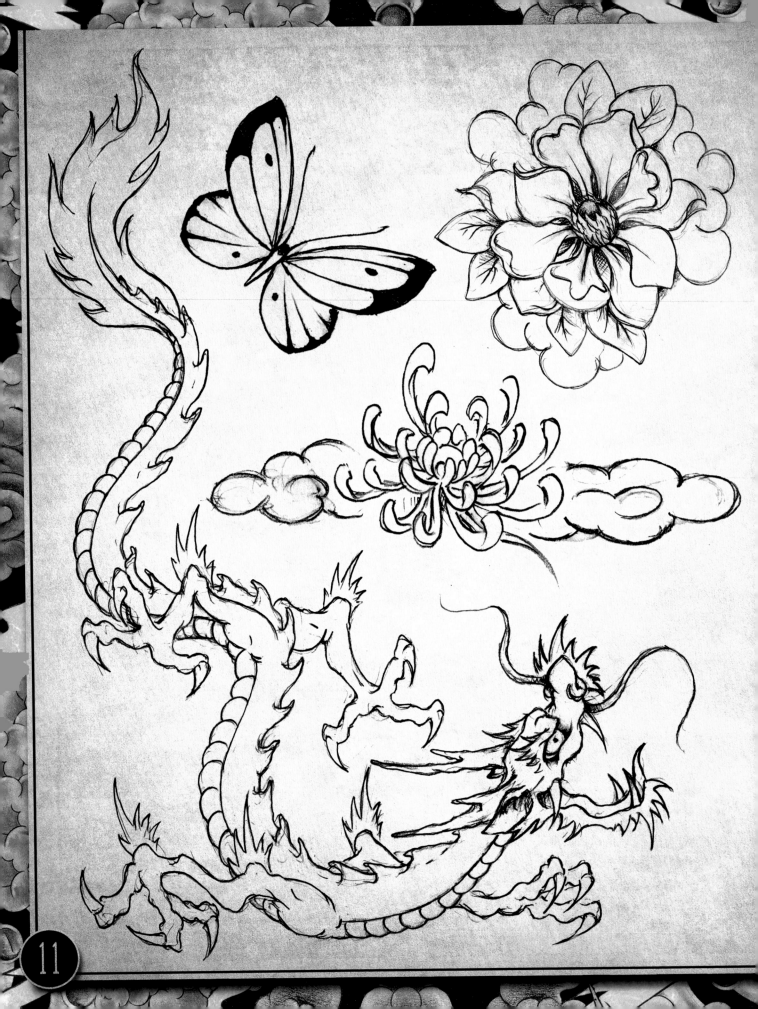

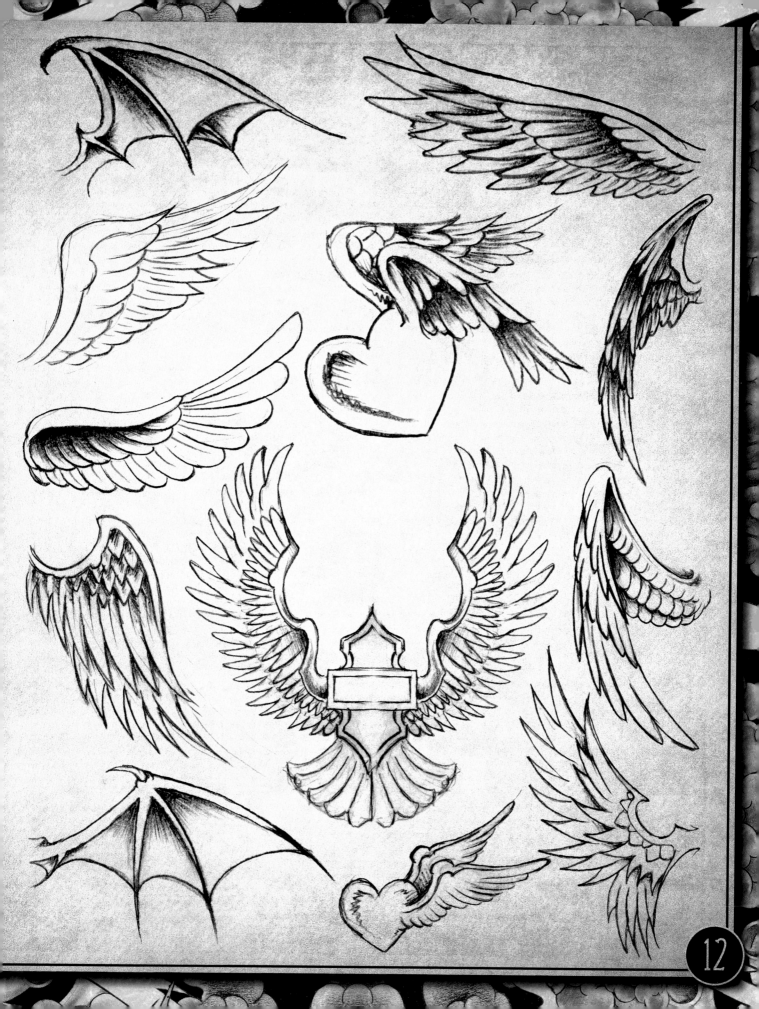

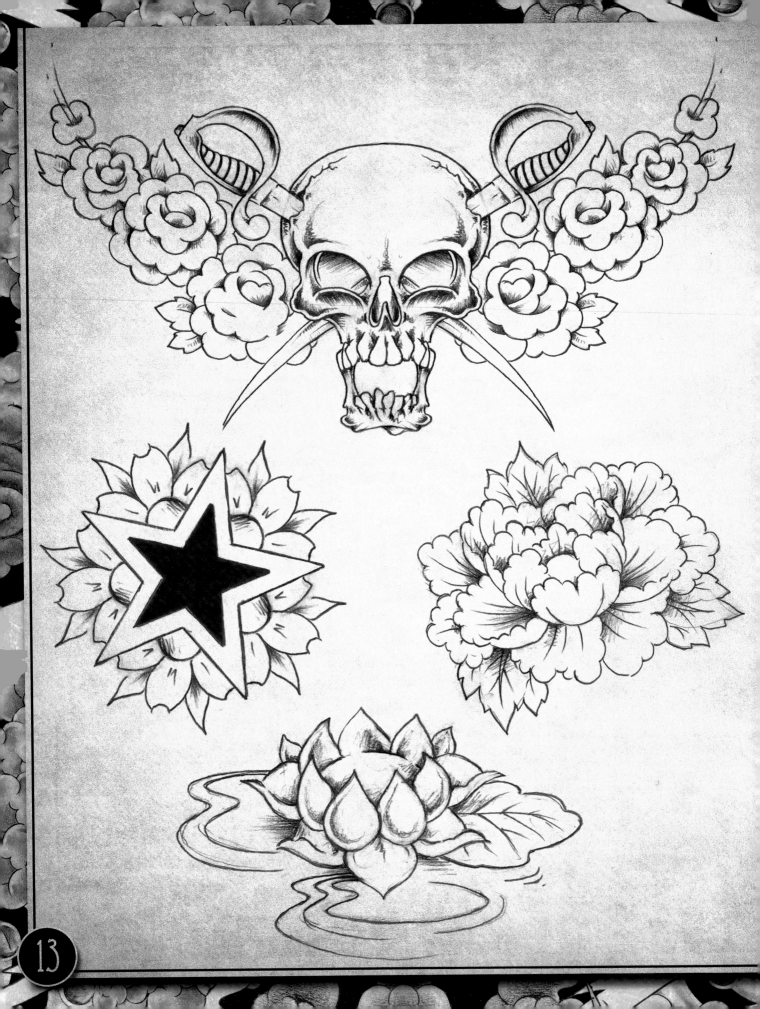

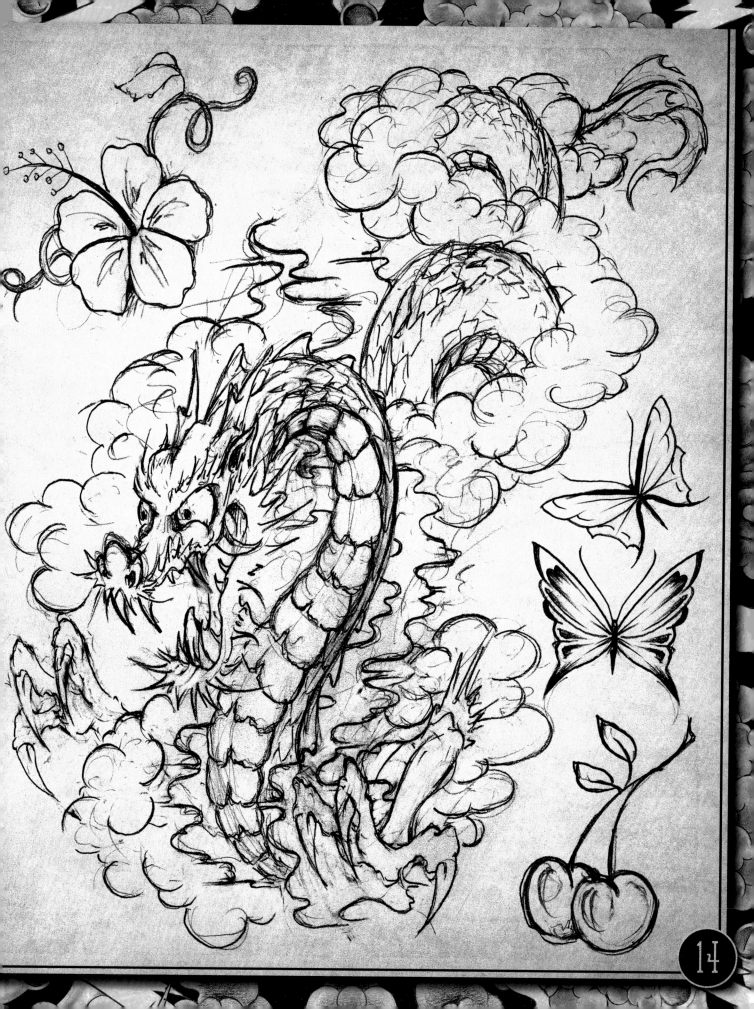

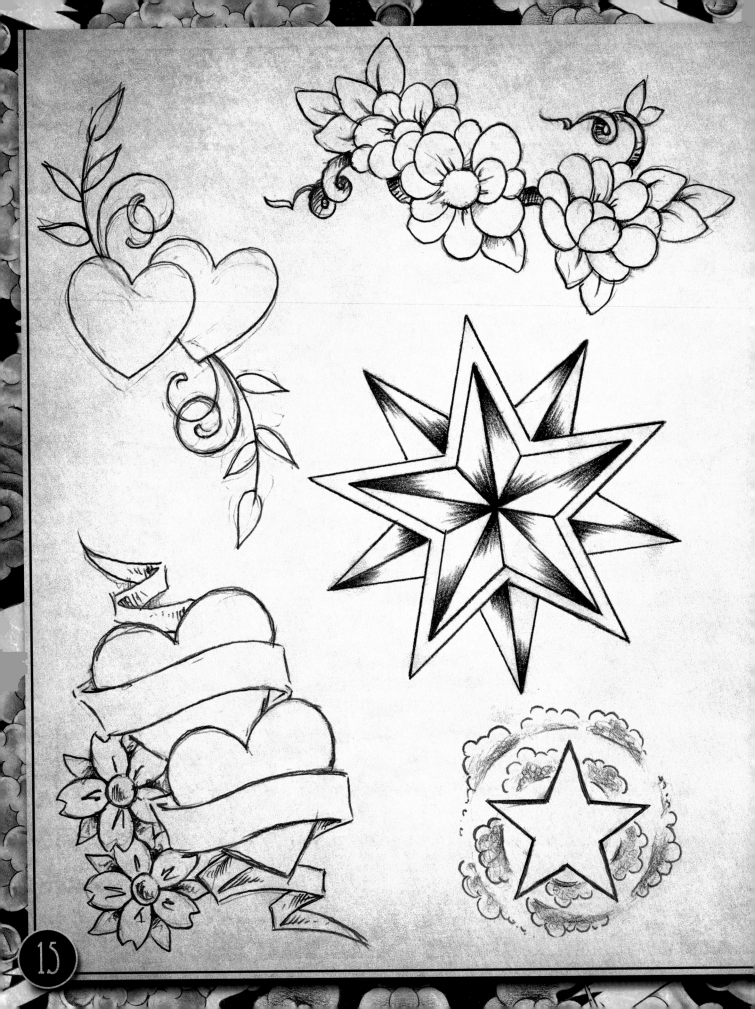

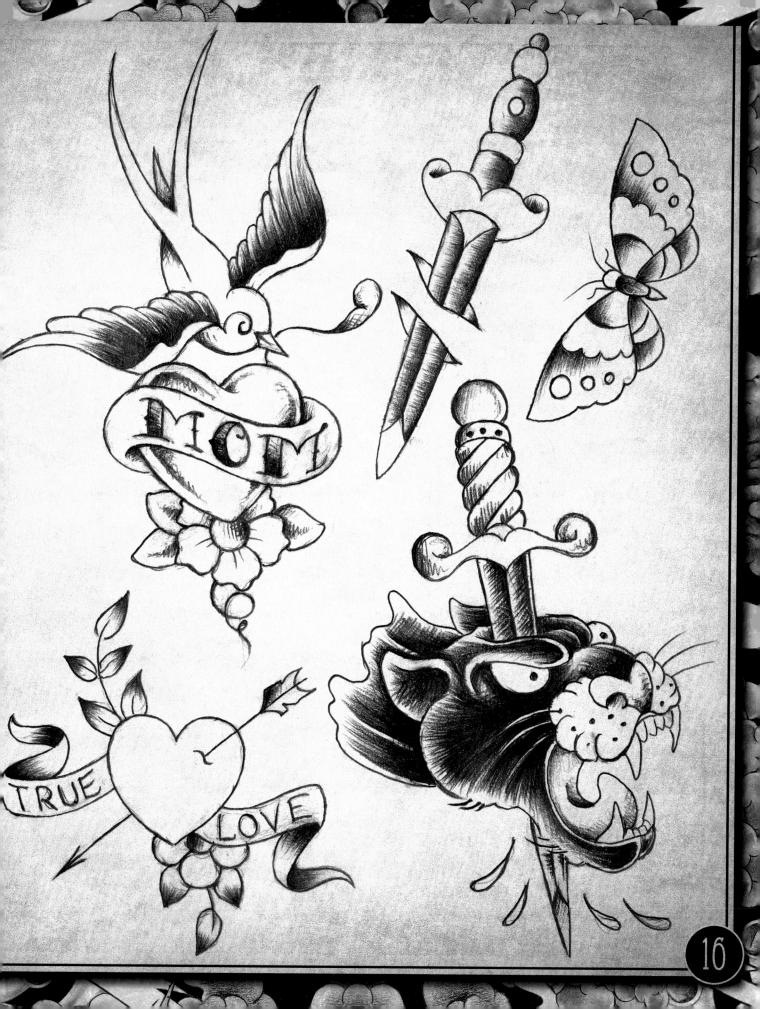

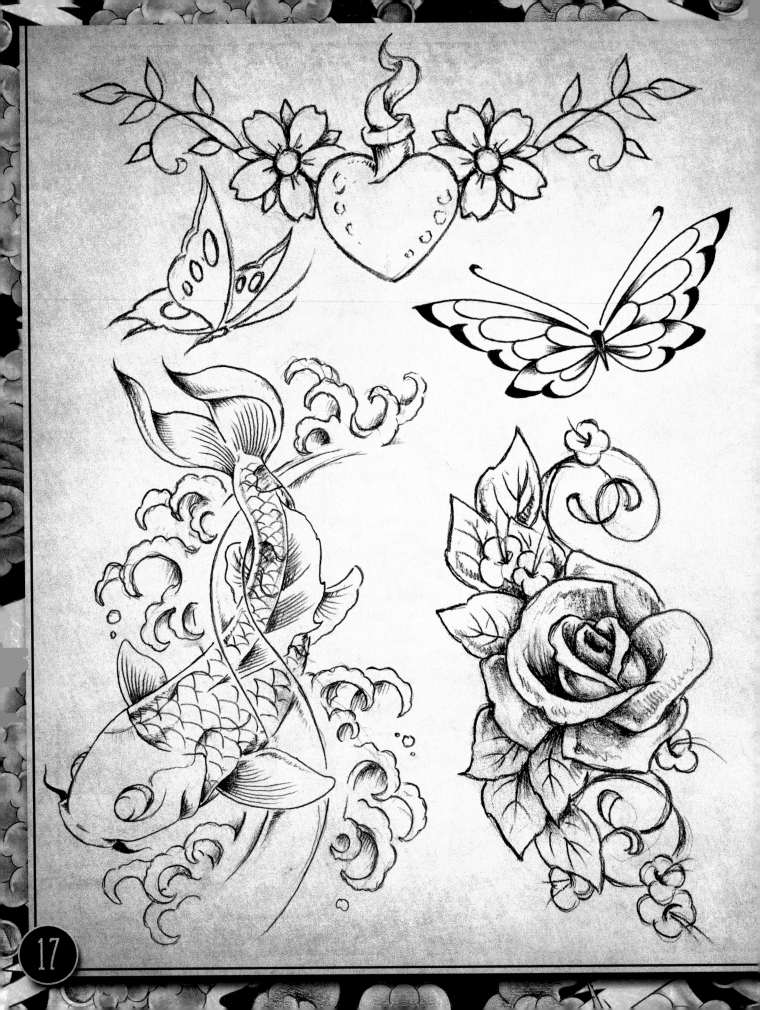

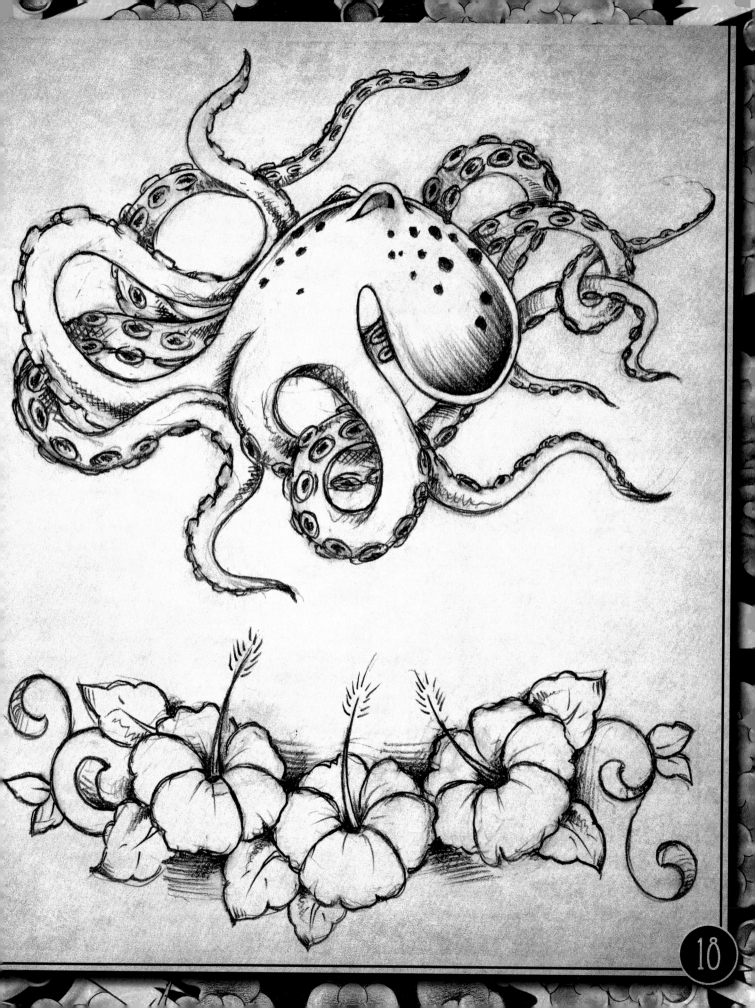

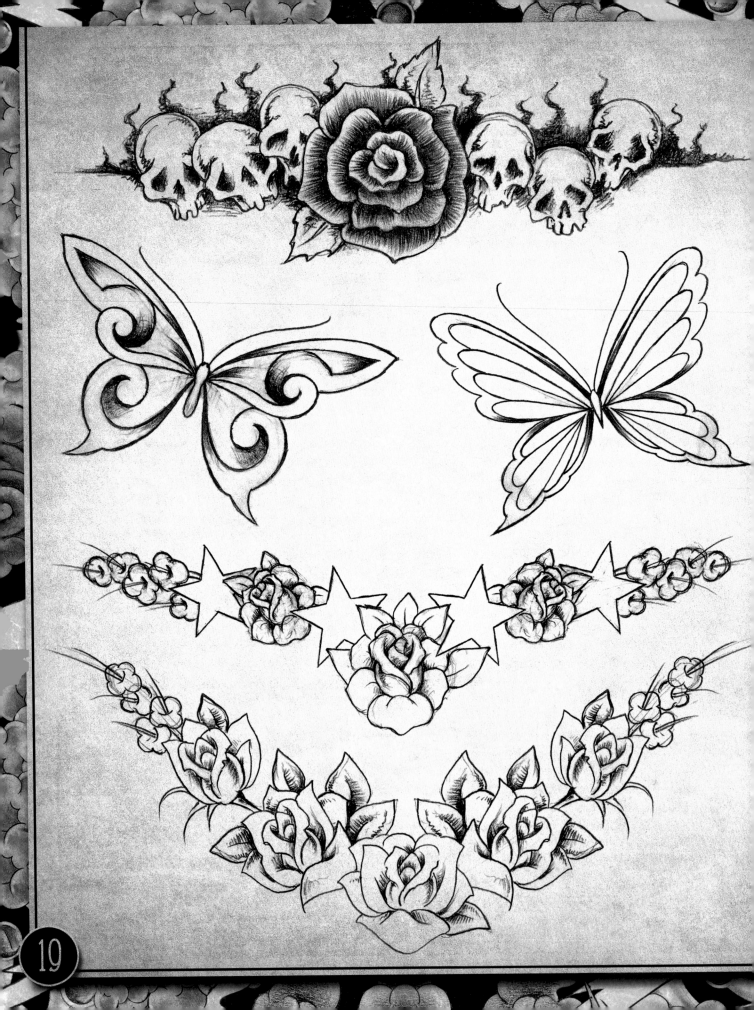

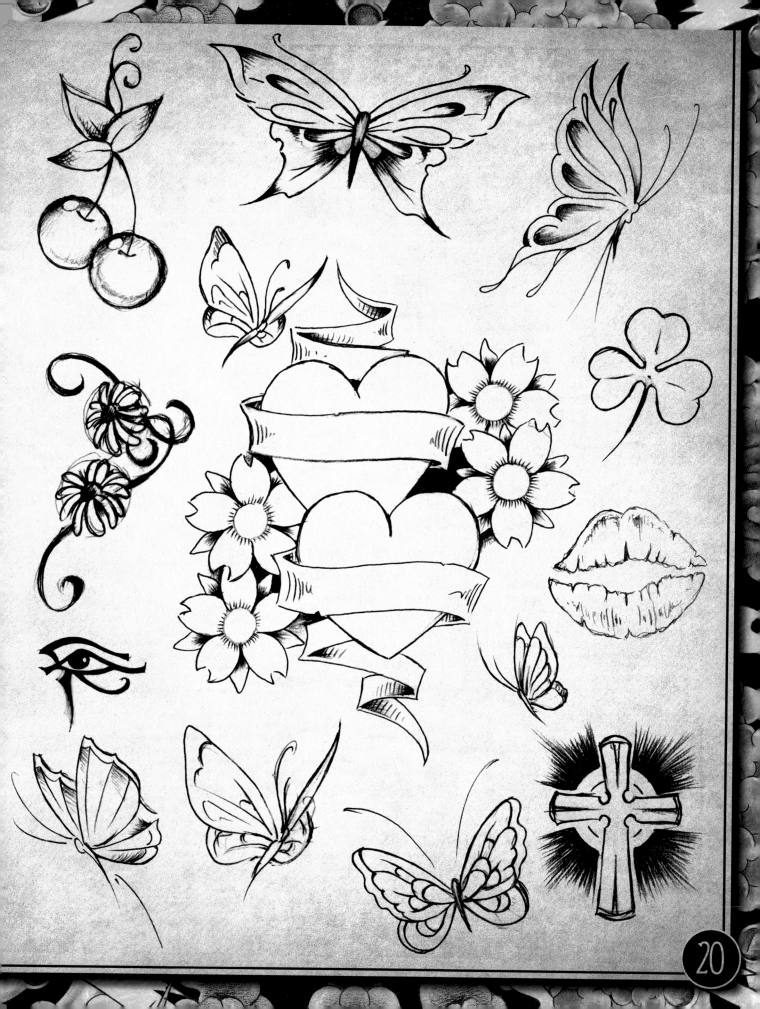

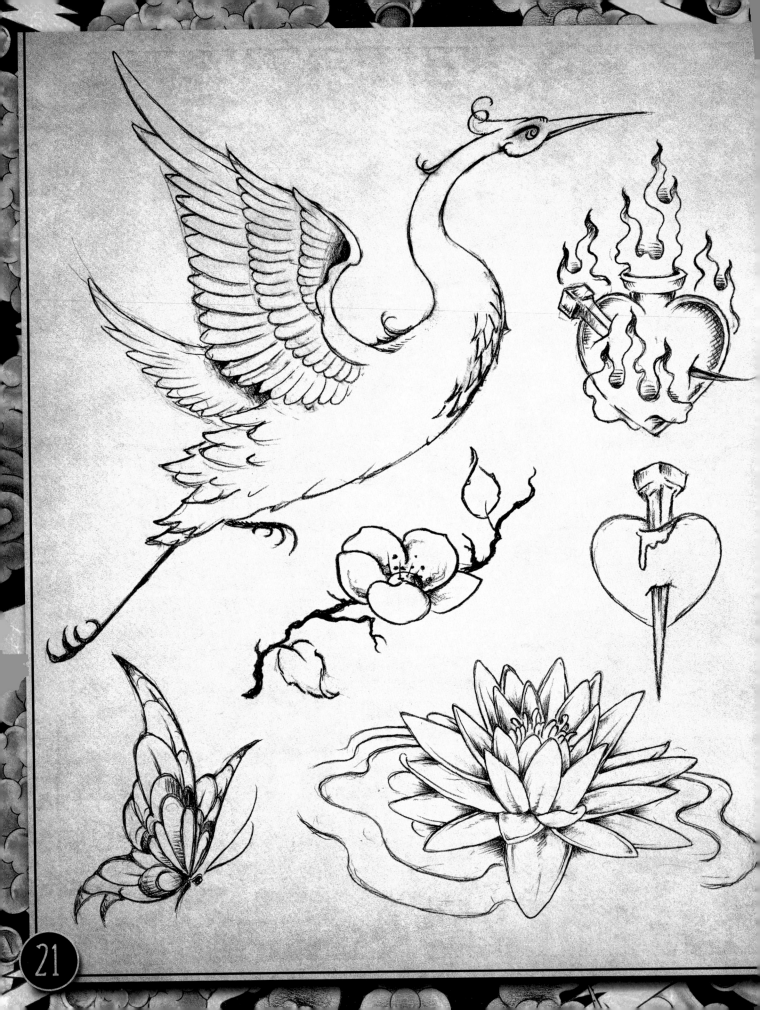

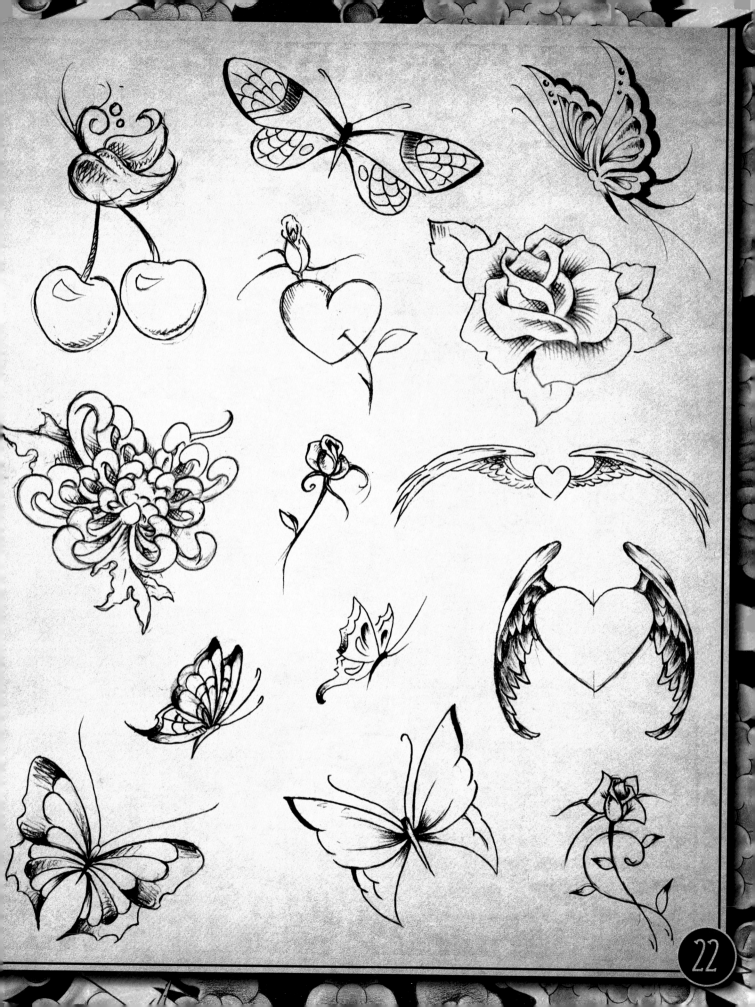

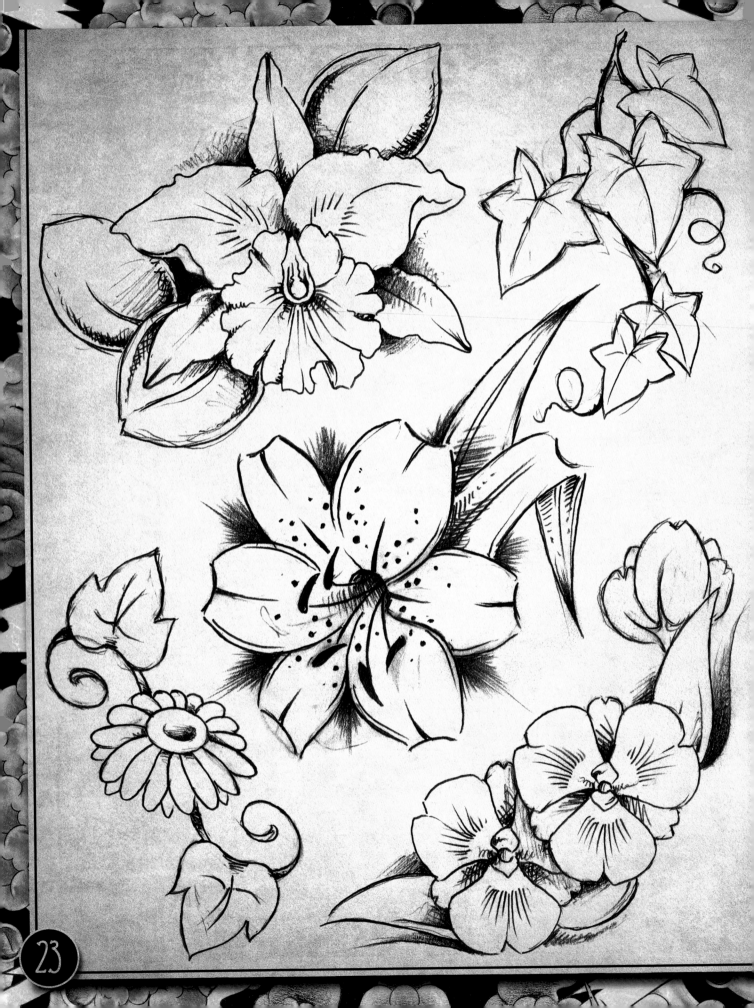

23

ABCDEFGHIJK
LMNOPQRS
TUVWXYZ

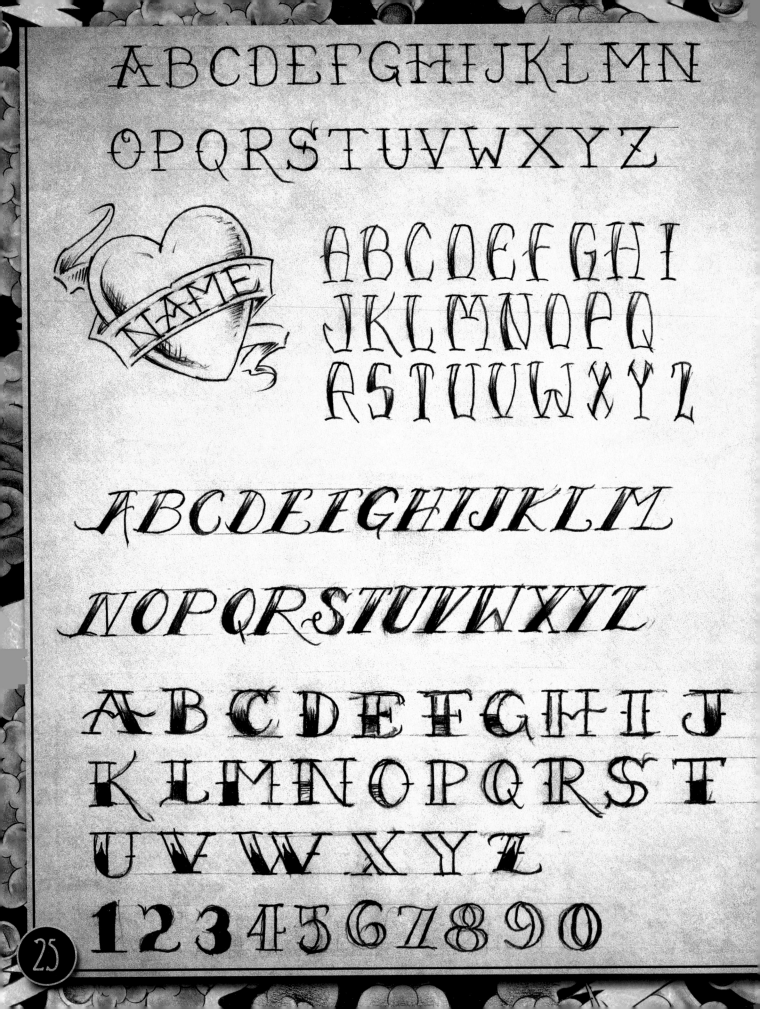

ABCDEFGHIJKLMN
OPQRSTUVWXYZ

ABCDEFGHI
JKLMNOPQ
RSTUVWXYZ

ABCDEFGHIJKLM
NOPQRSTUVWXYZ

ABCDEFGHIIJ
KLMNOPQRST
UVWXYZ
1234567890

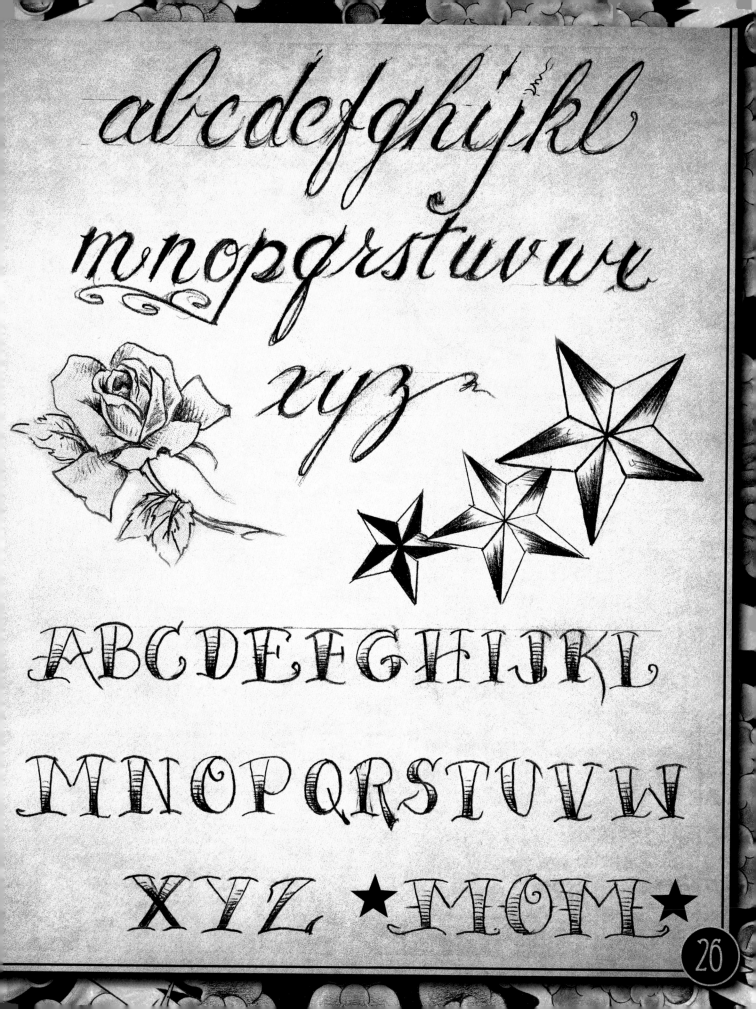

abcdefghijkl

mnopqrstuvwx

xyz

ABCDEFGHIJKL

MNOPQRSTUVW

XYZ ★ MOM ★

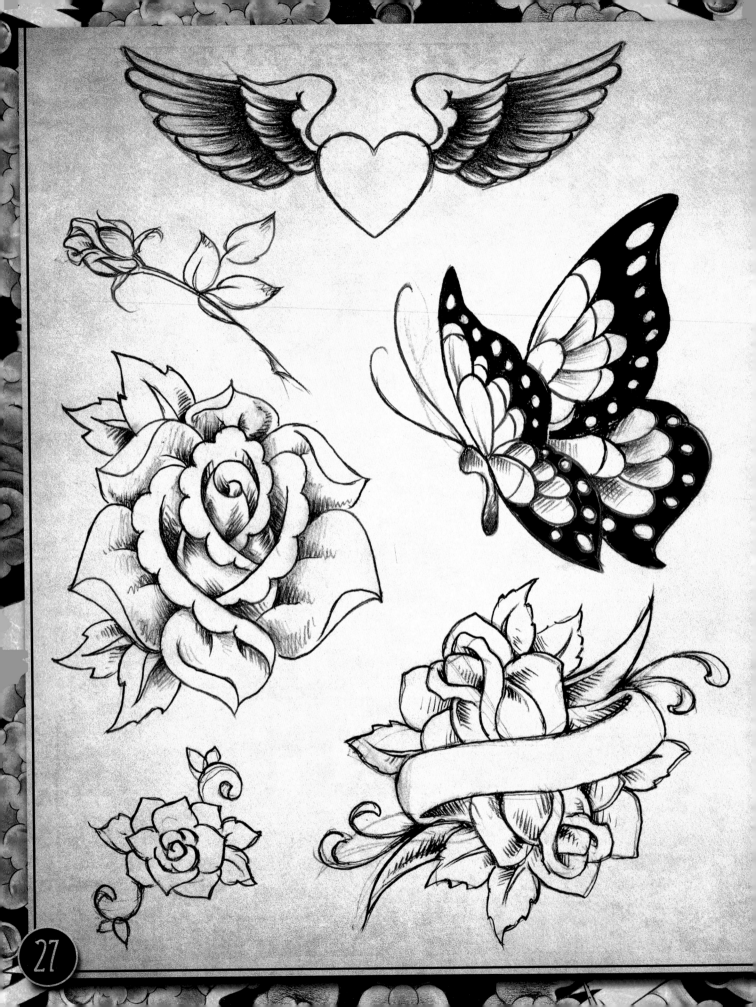

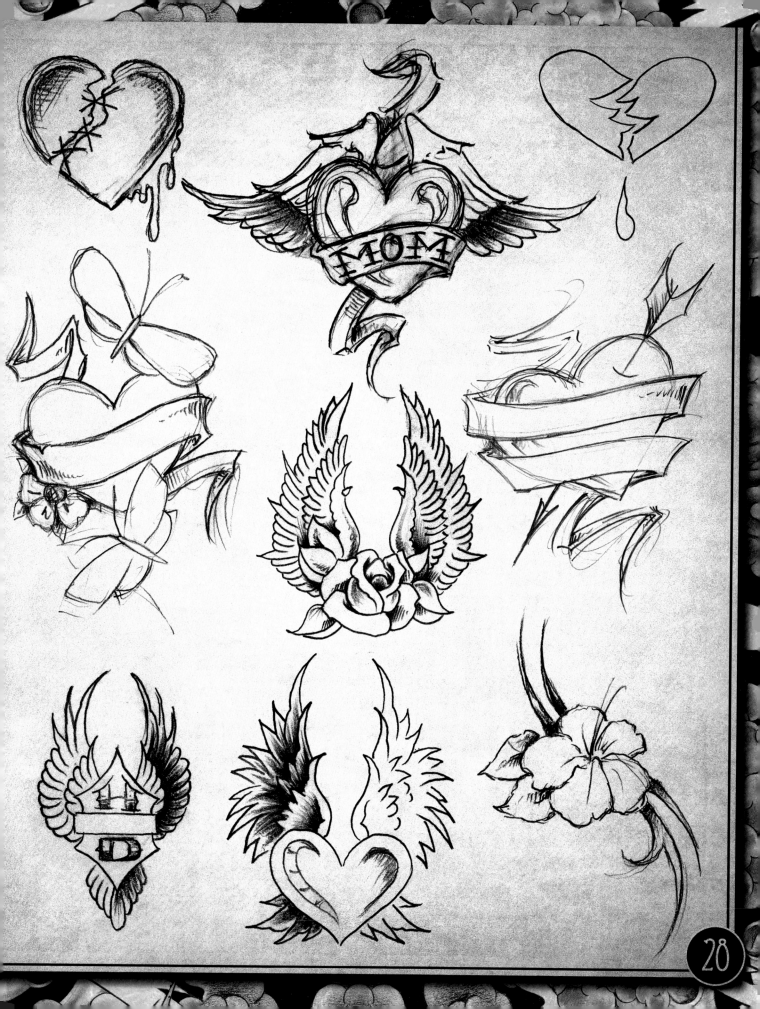

MOM

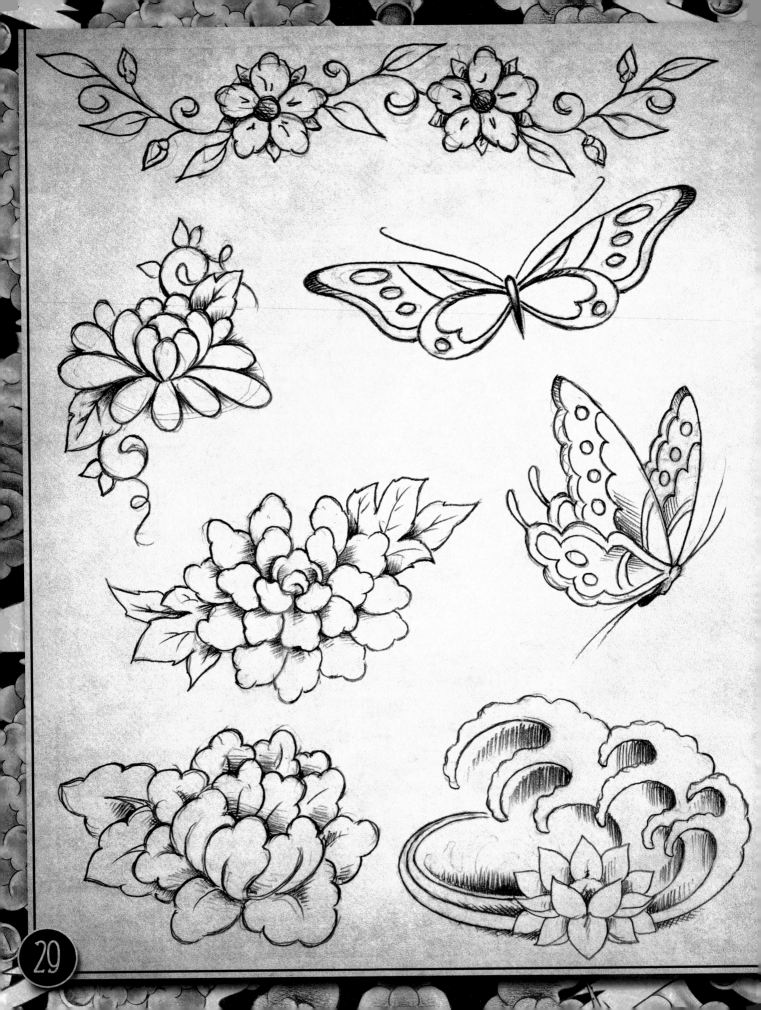

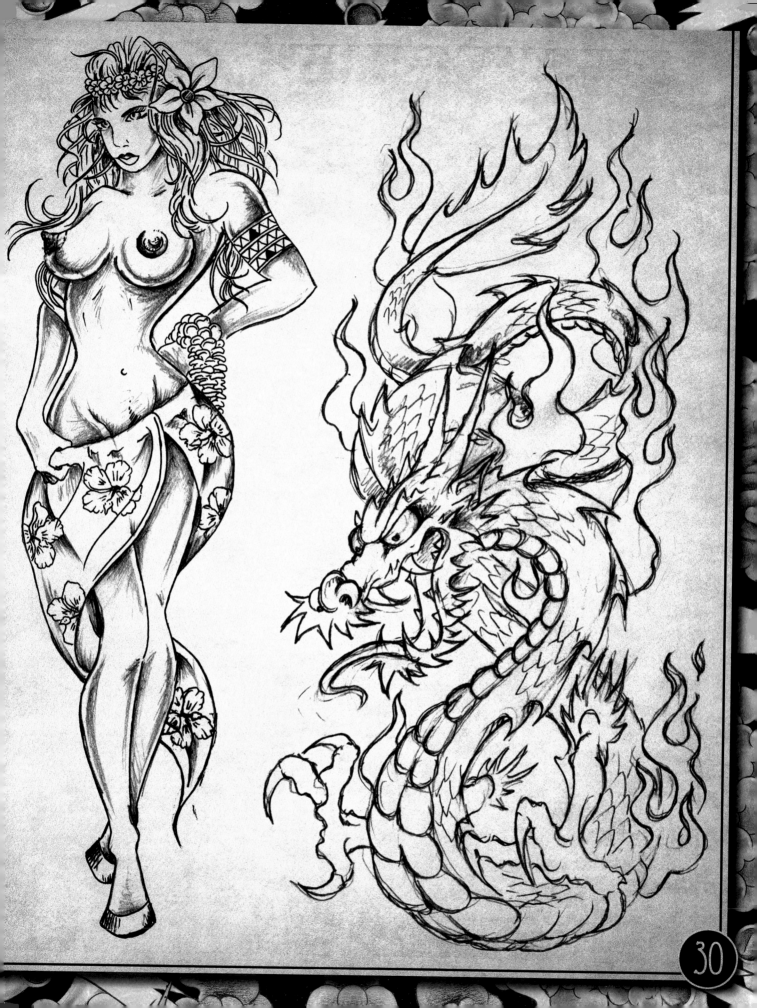

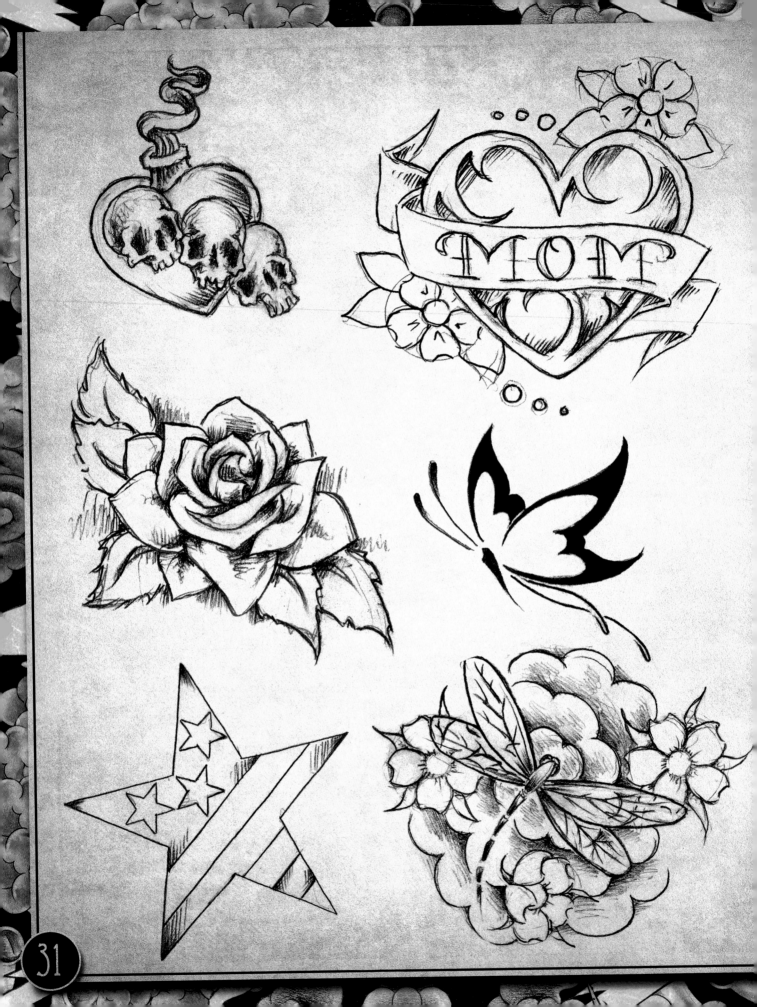

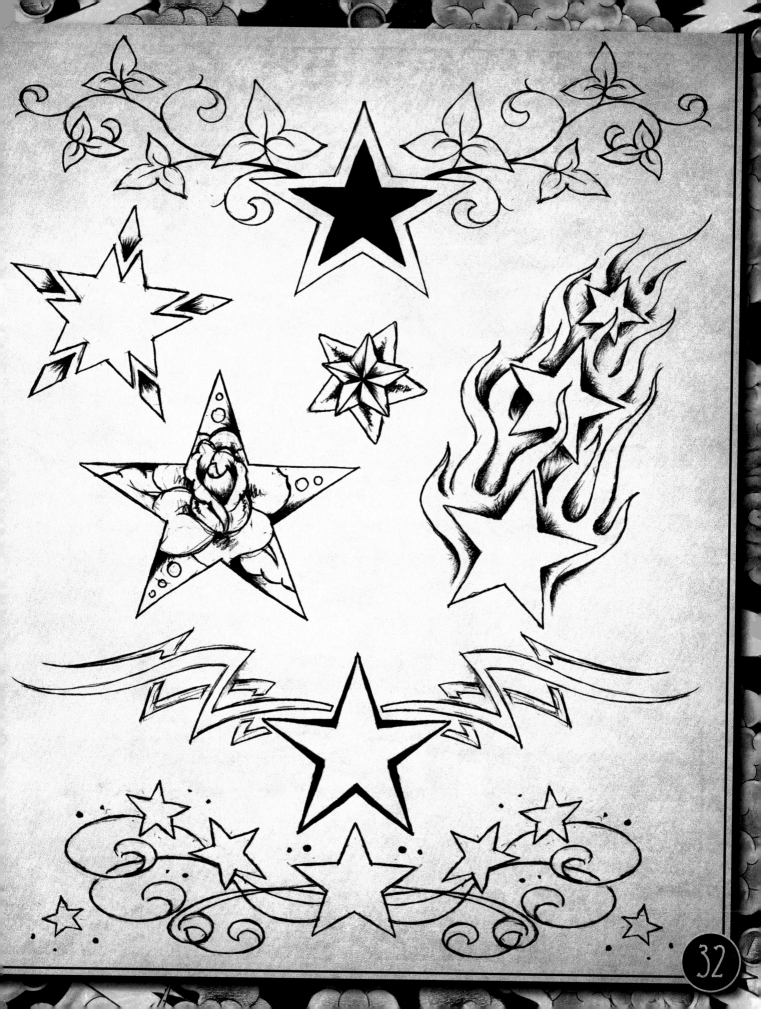

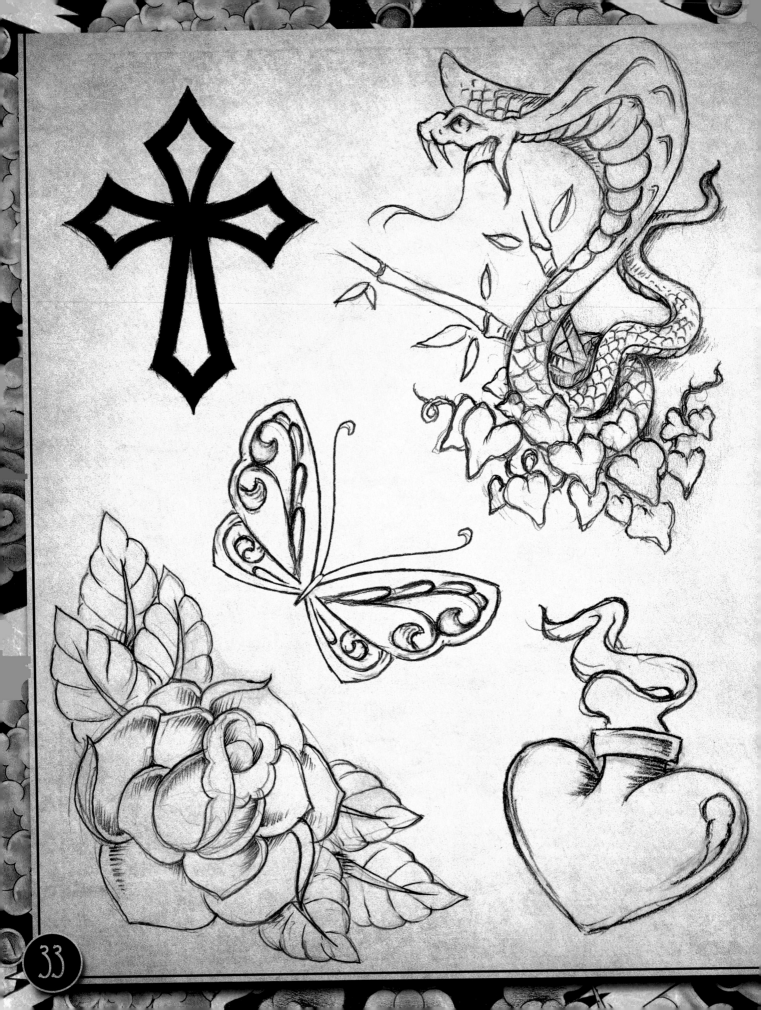

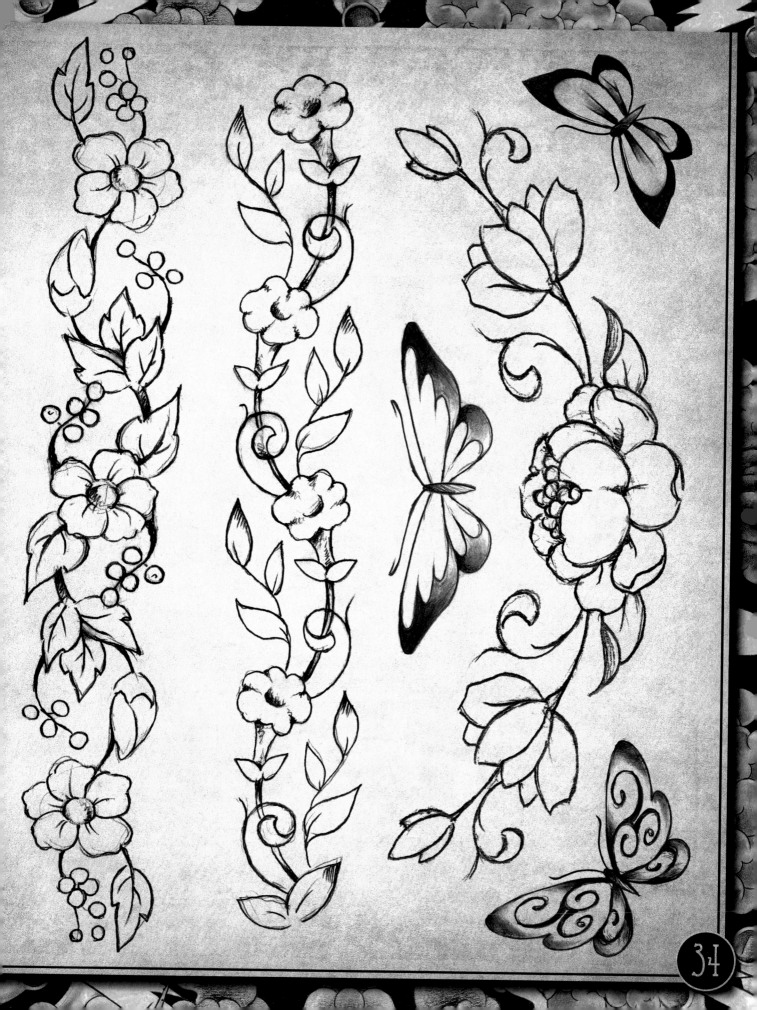

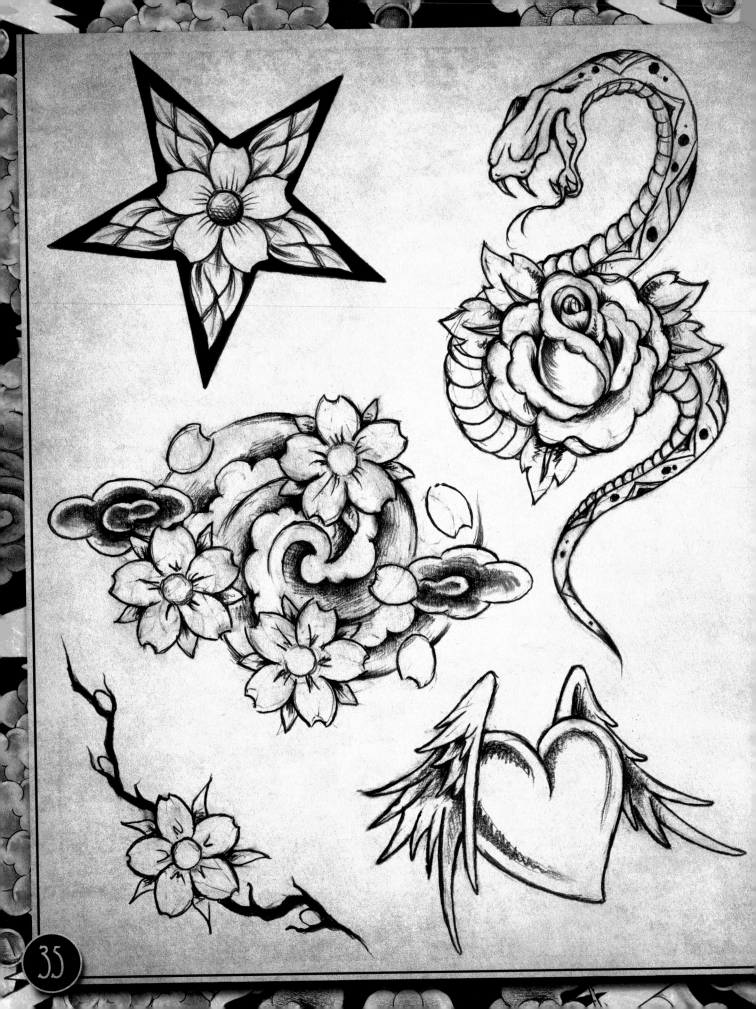

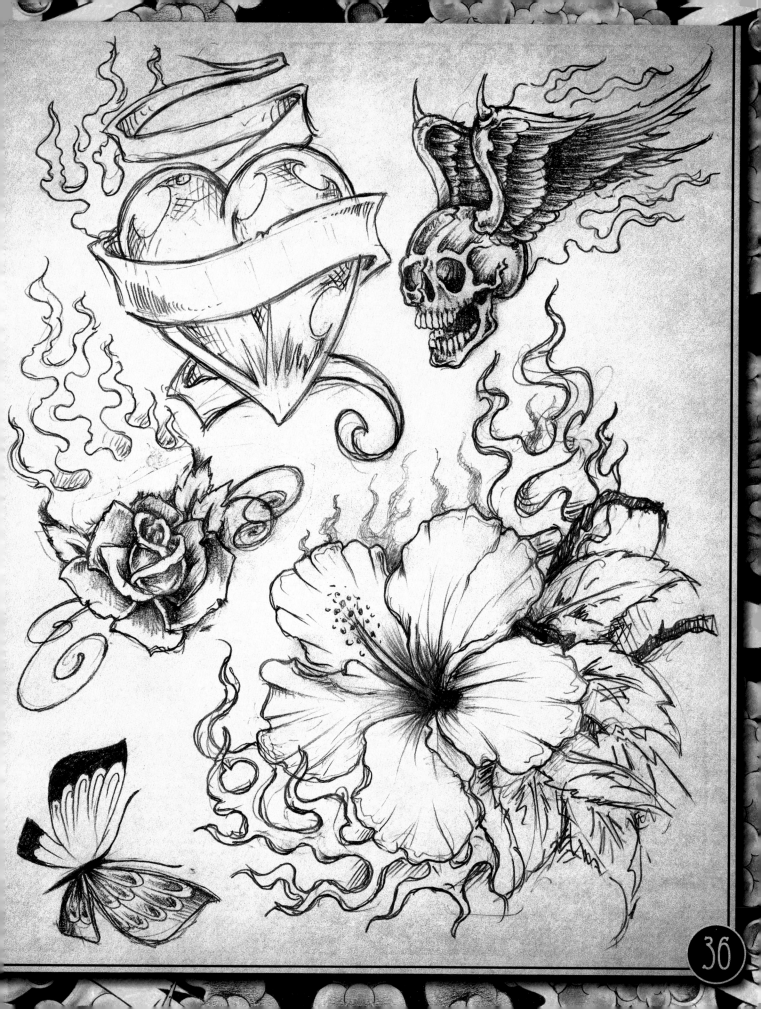

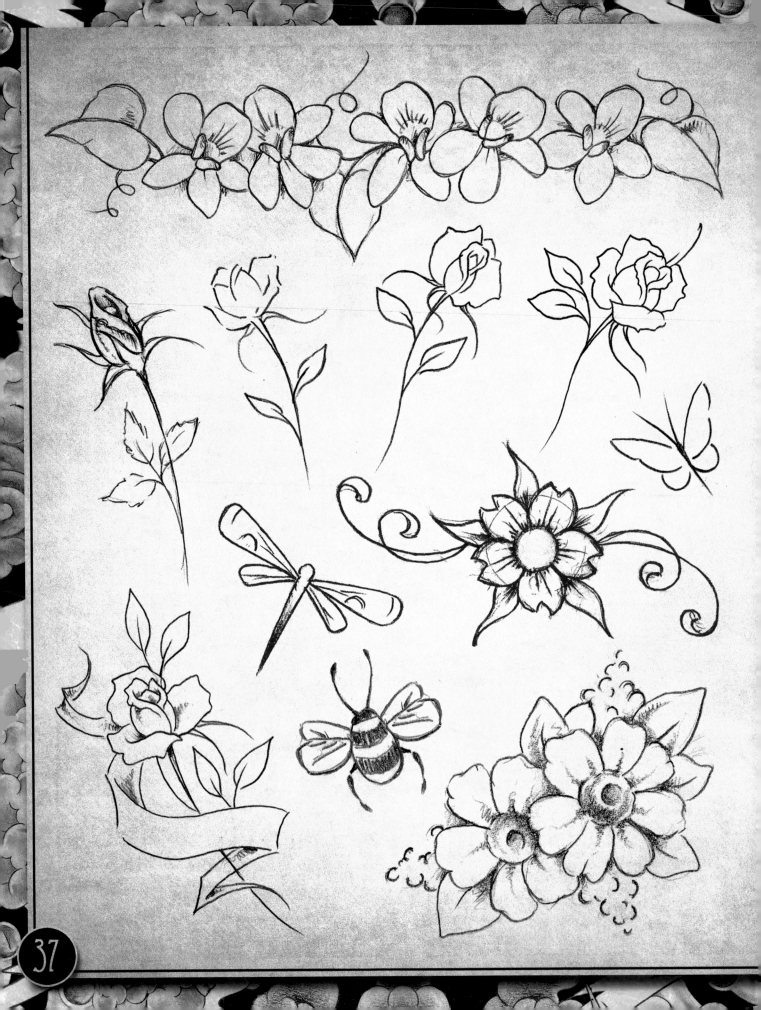

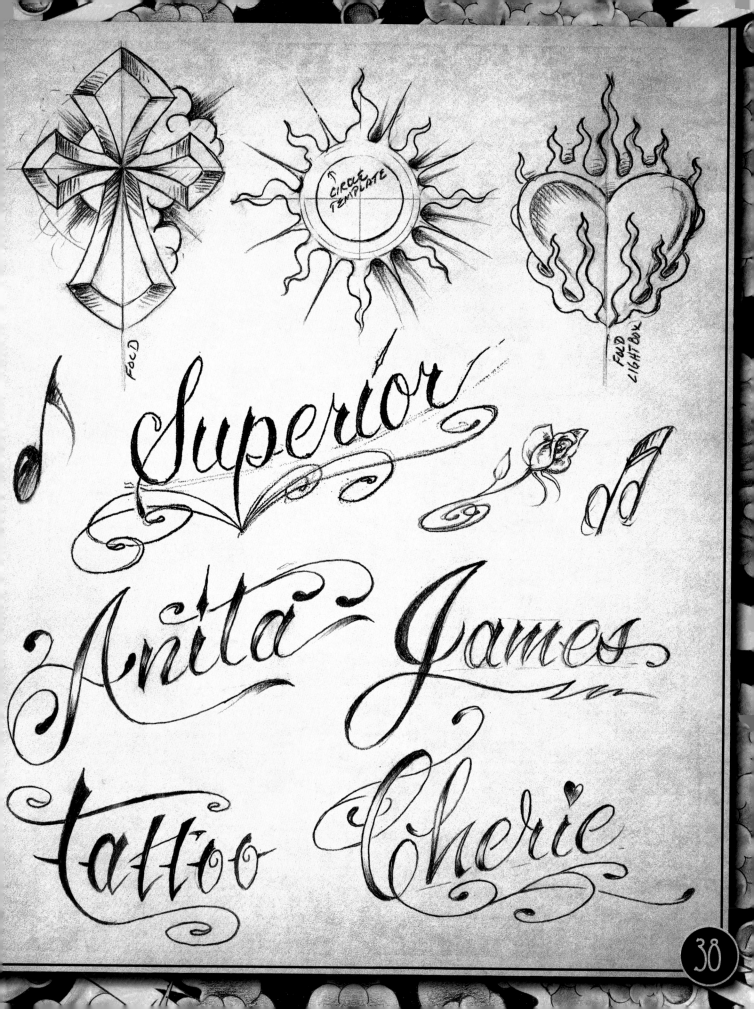

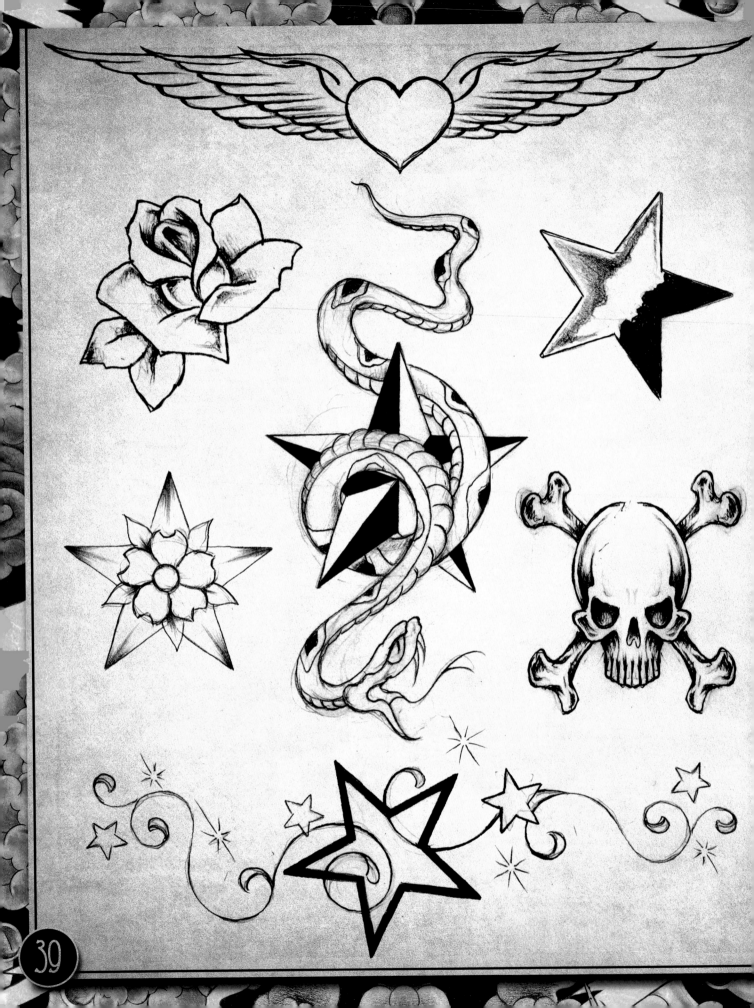

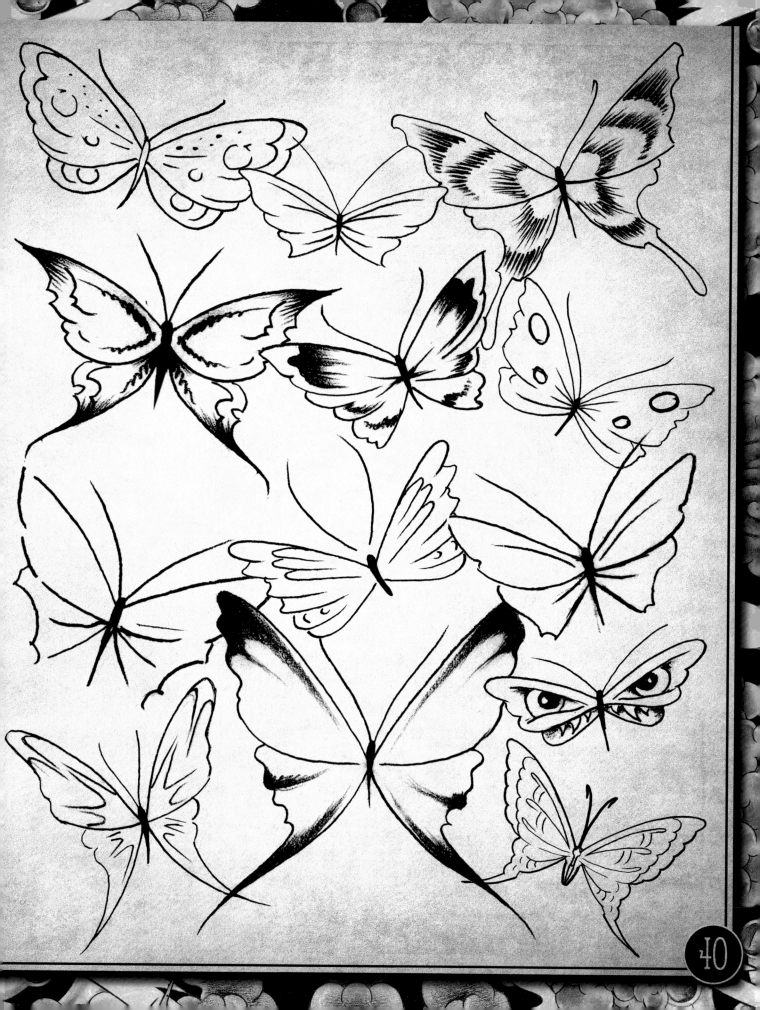

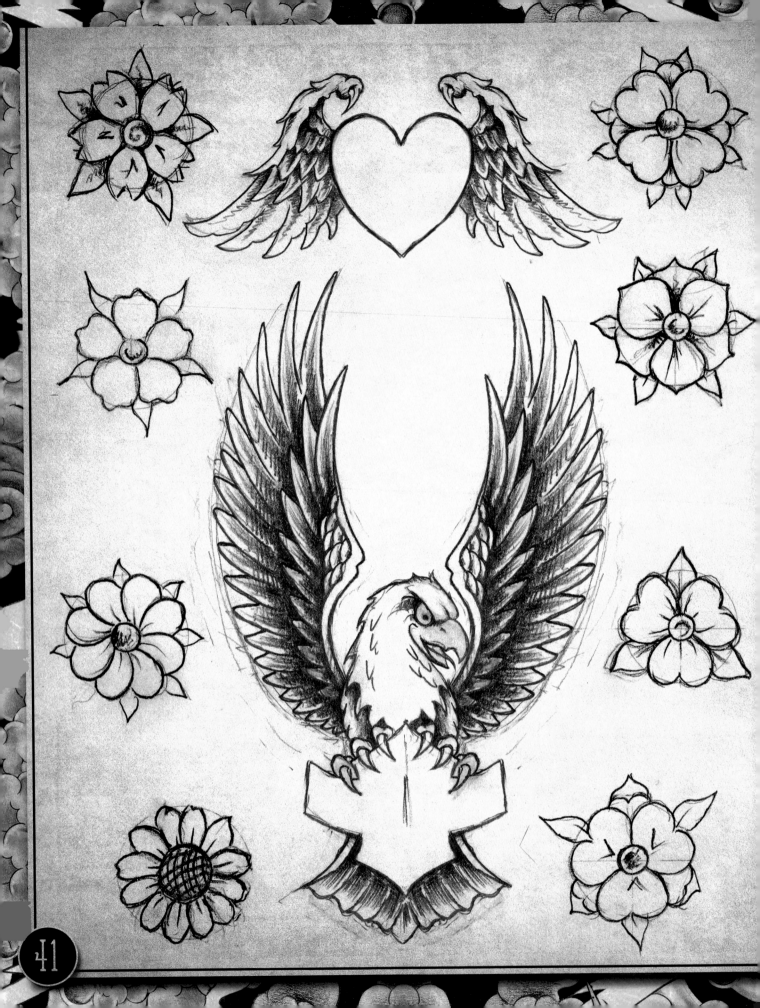

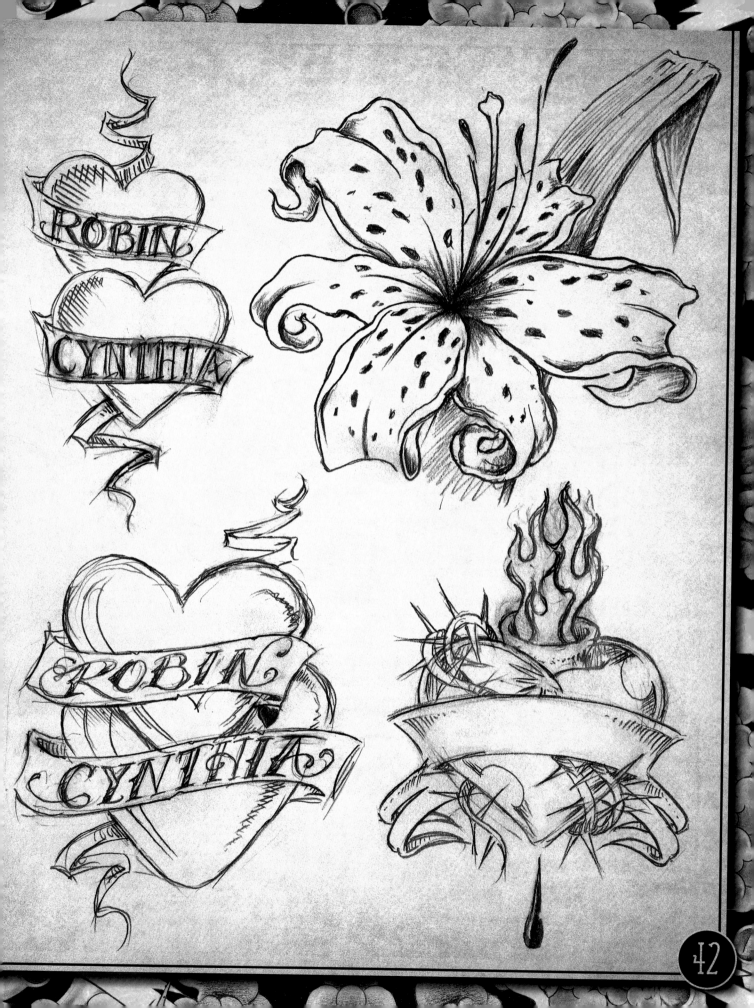

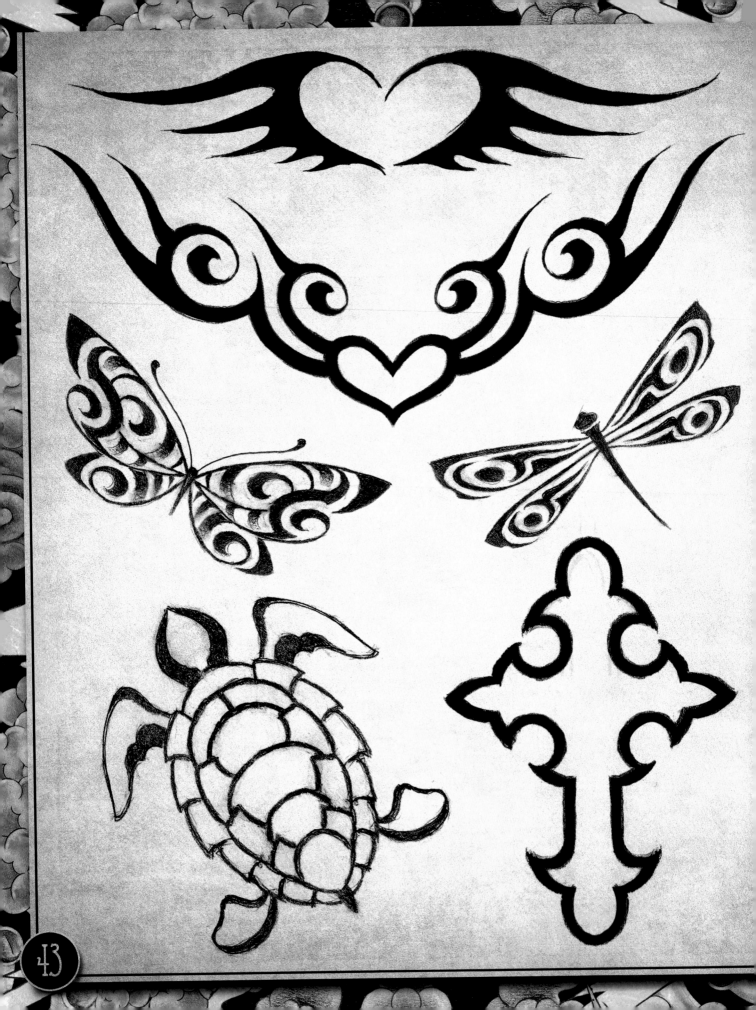

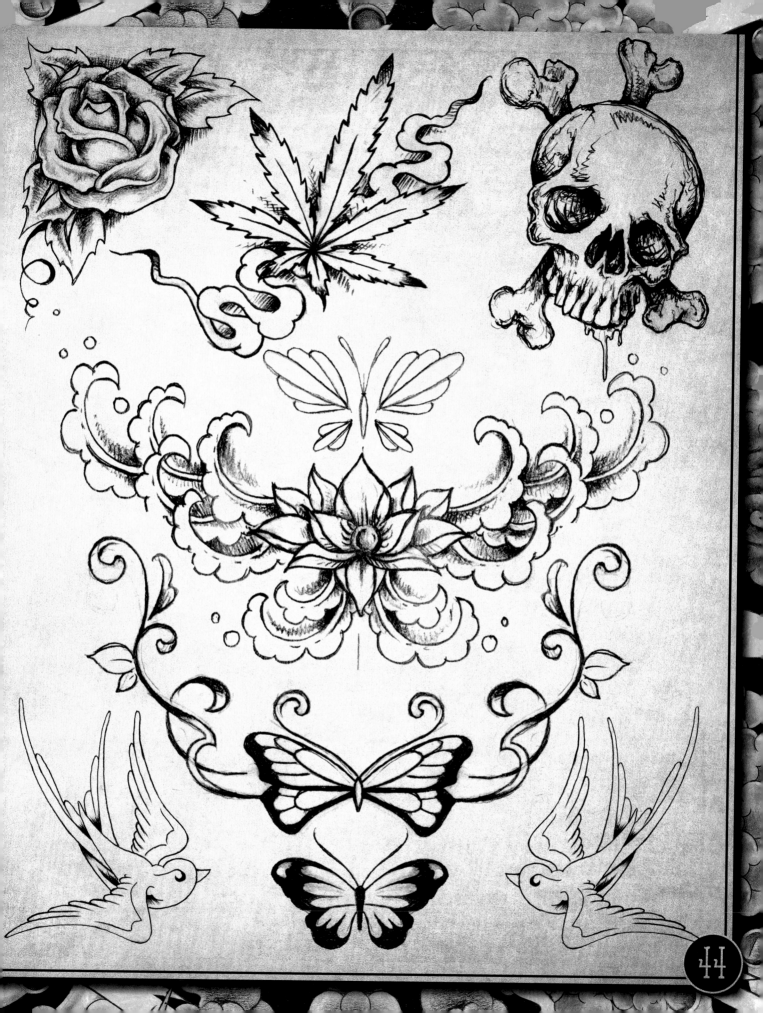

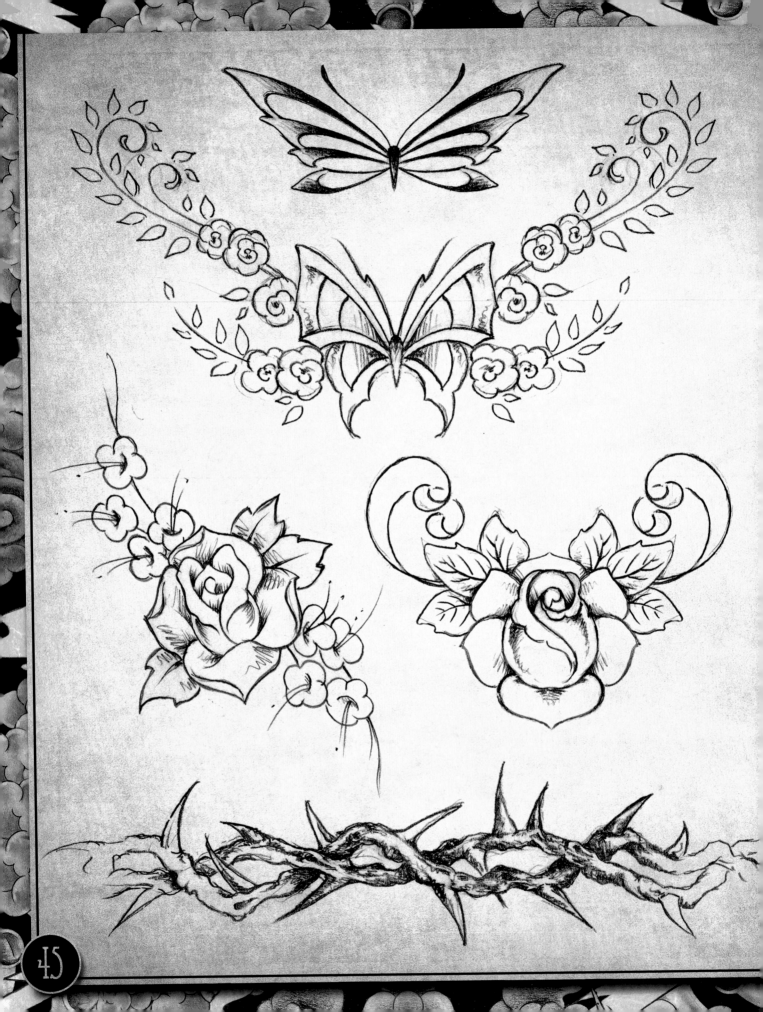

45

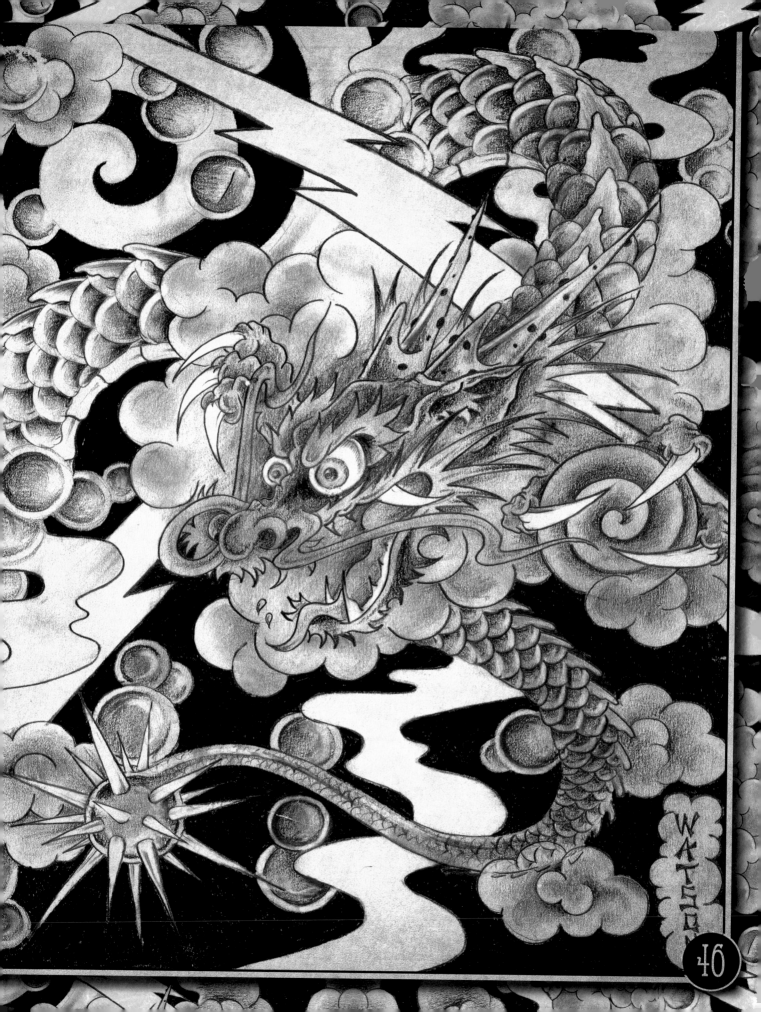

46

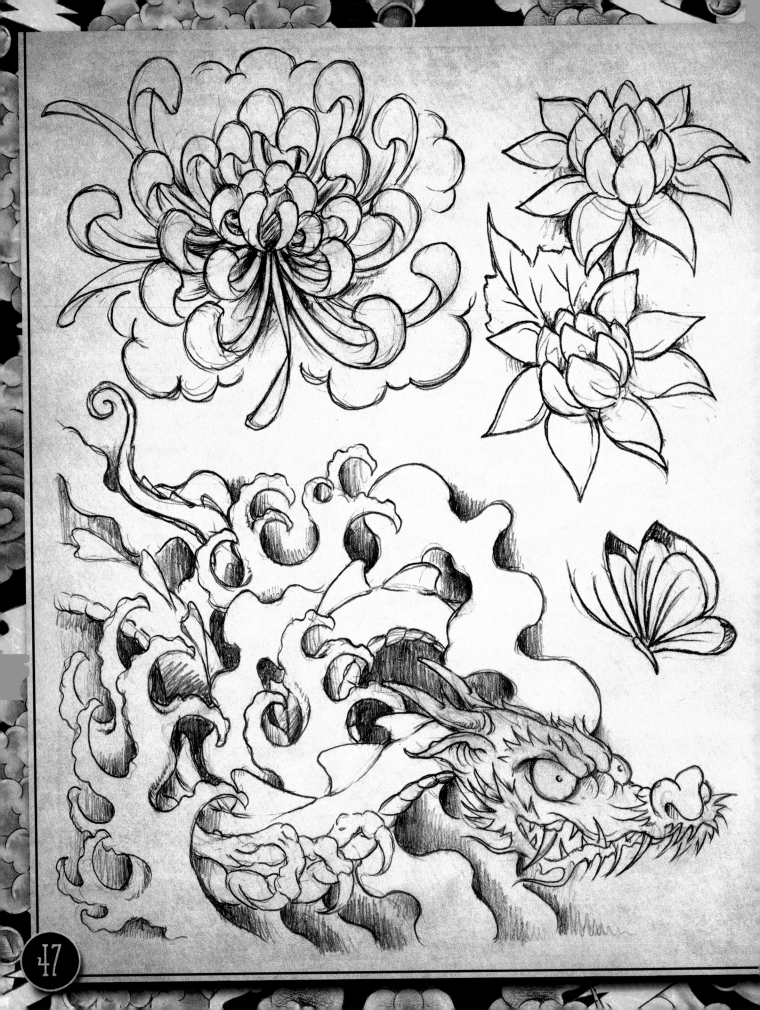

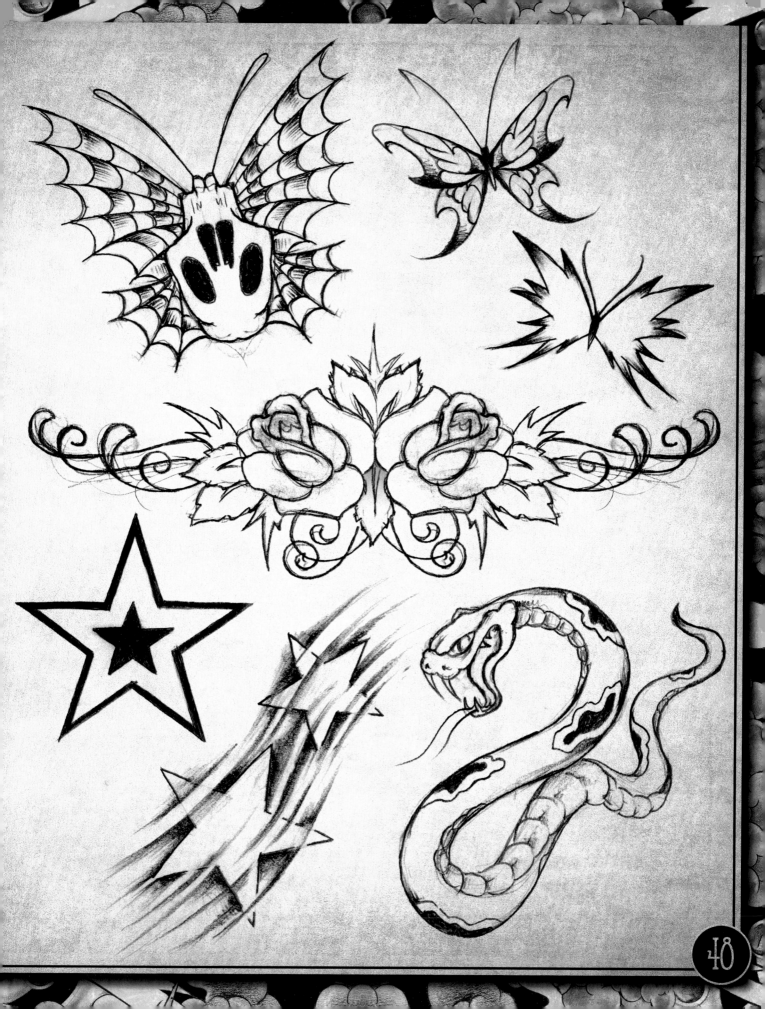

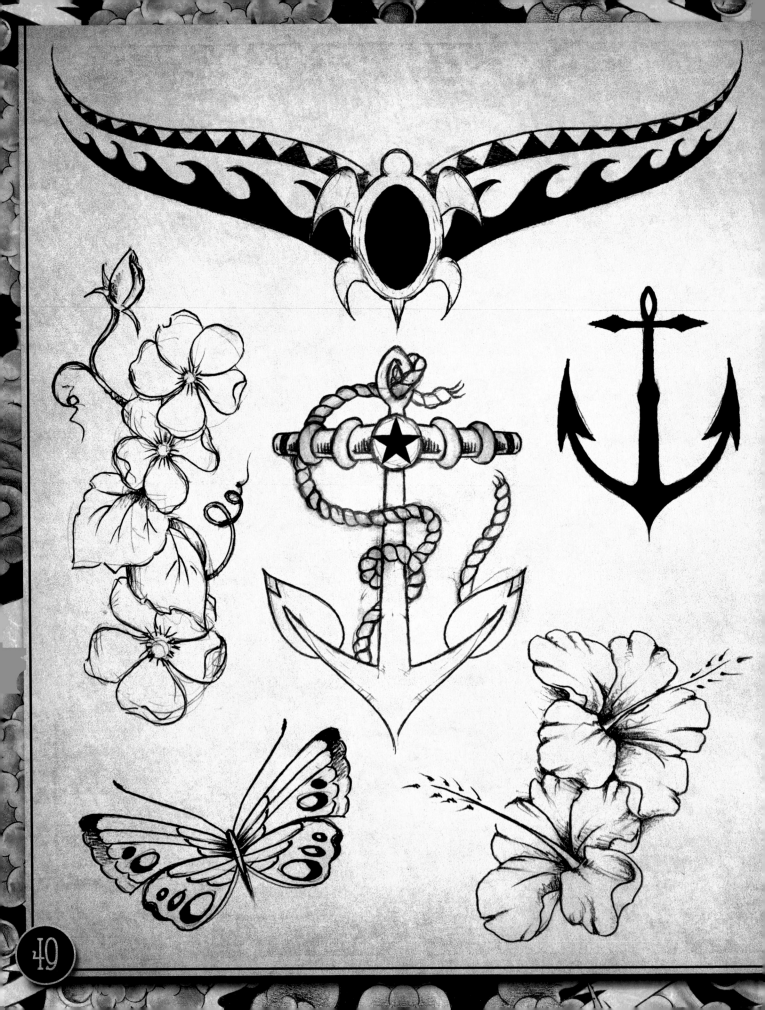

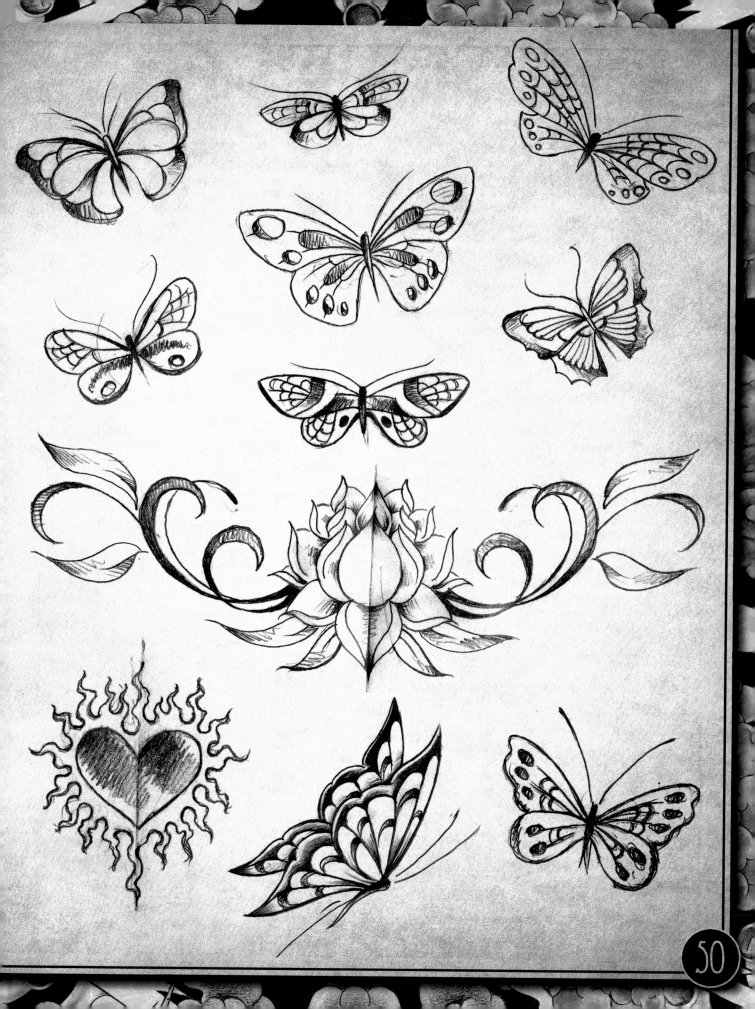

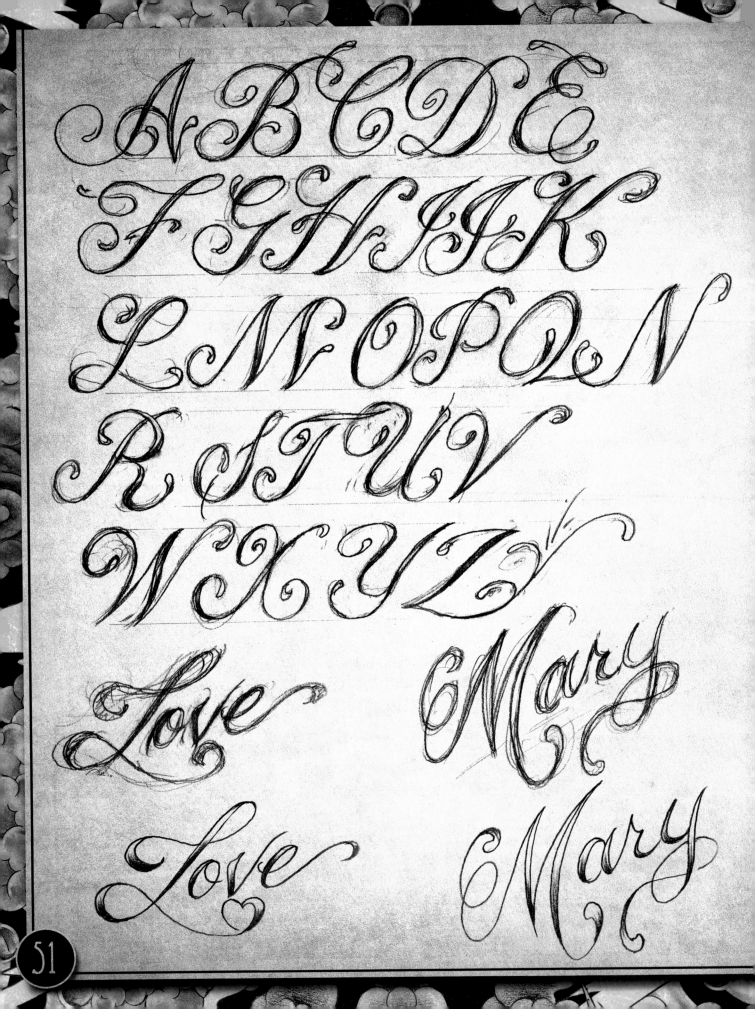

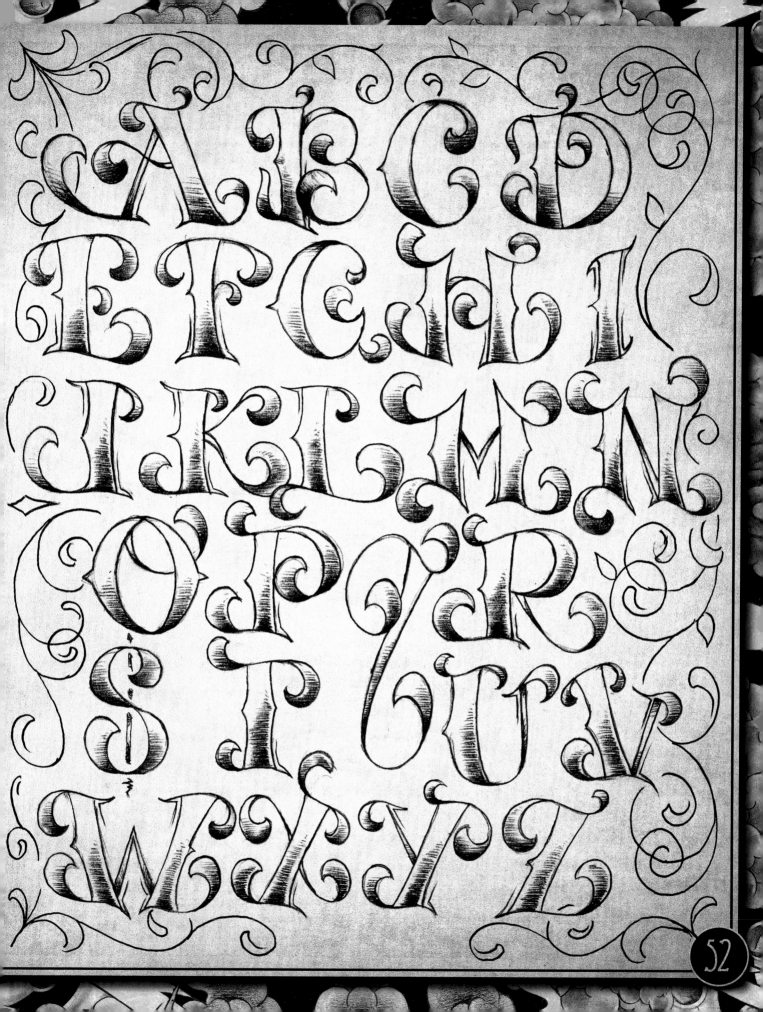

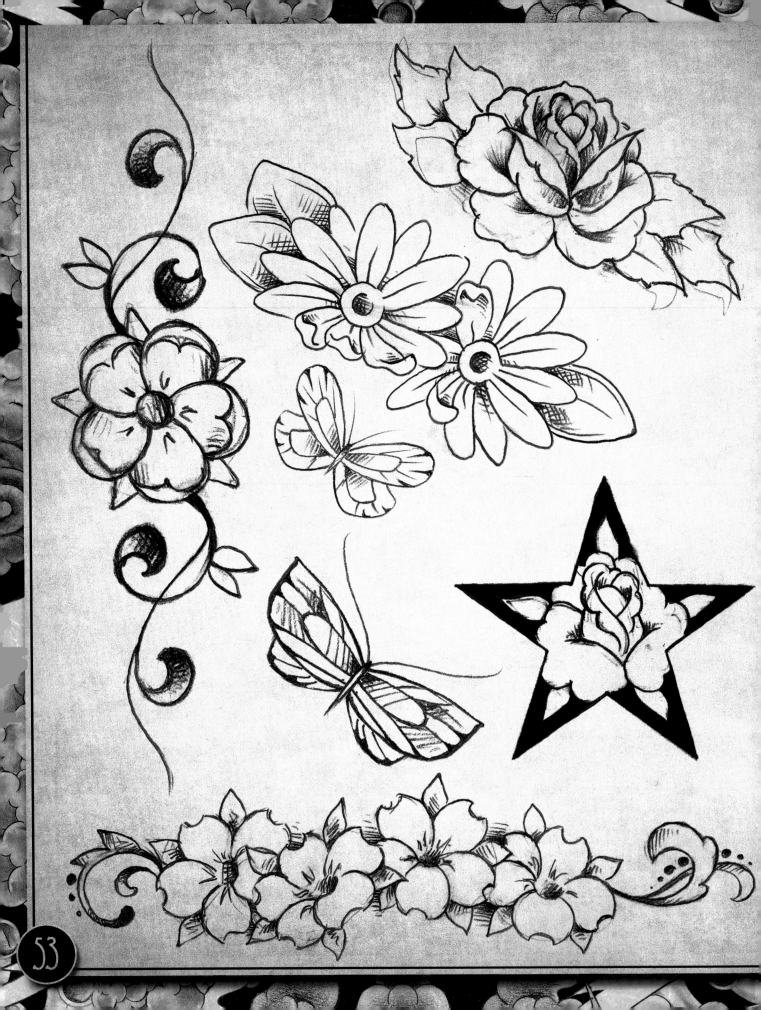

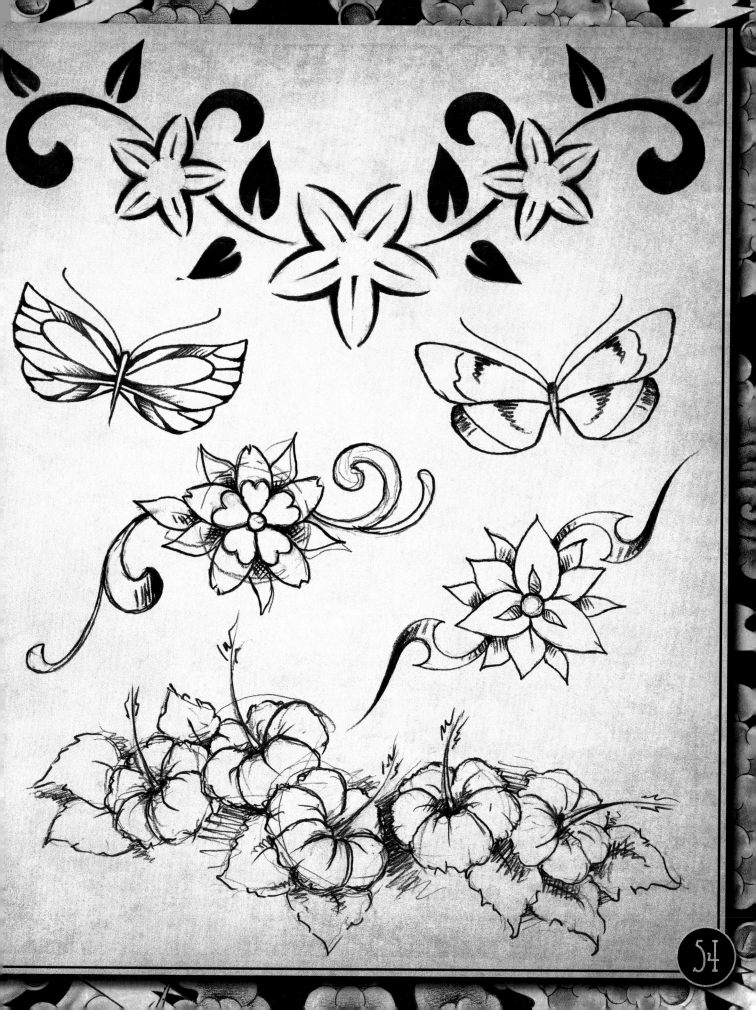

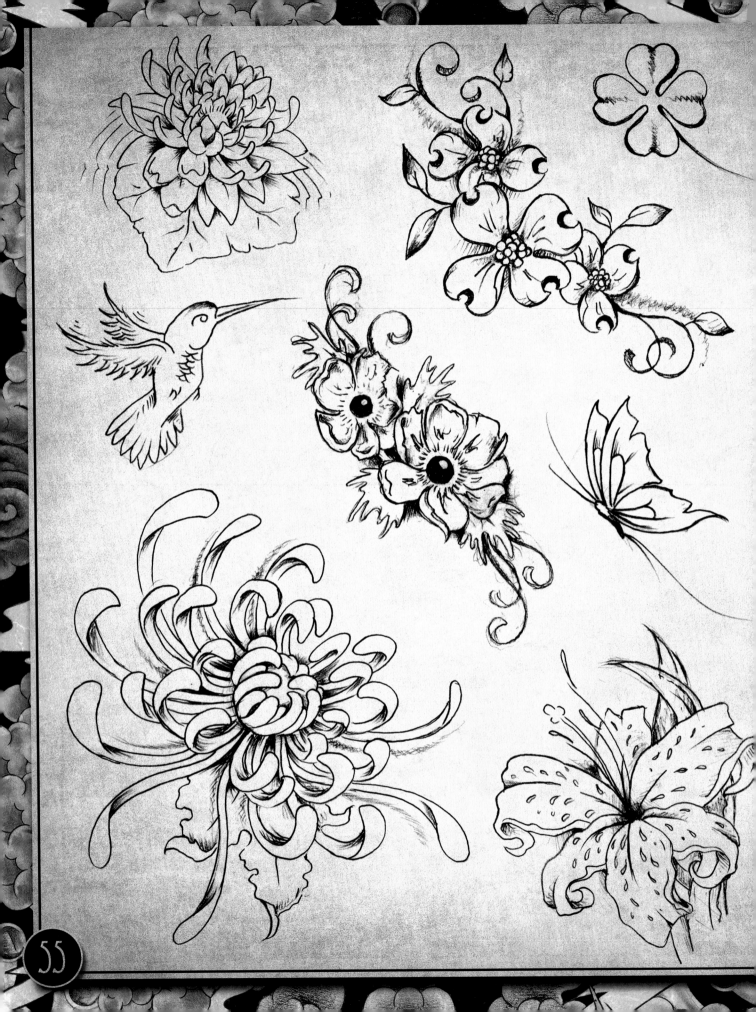

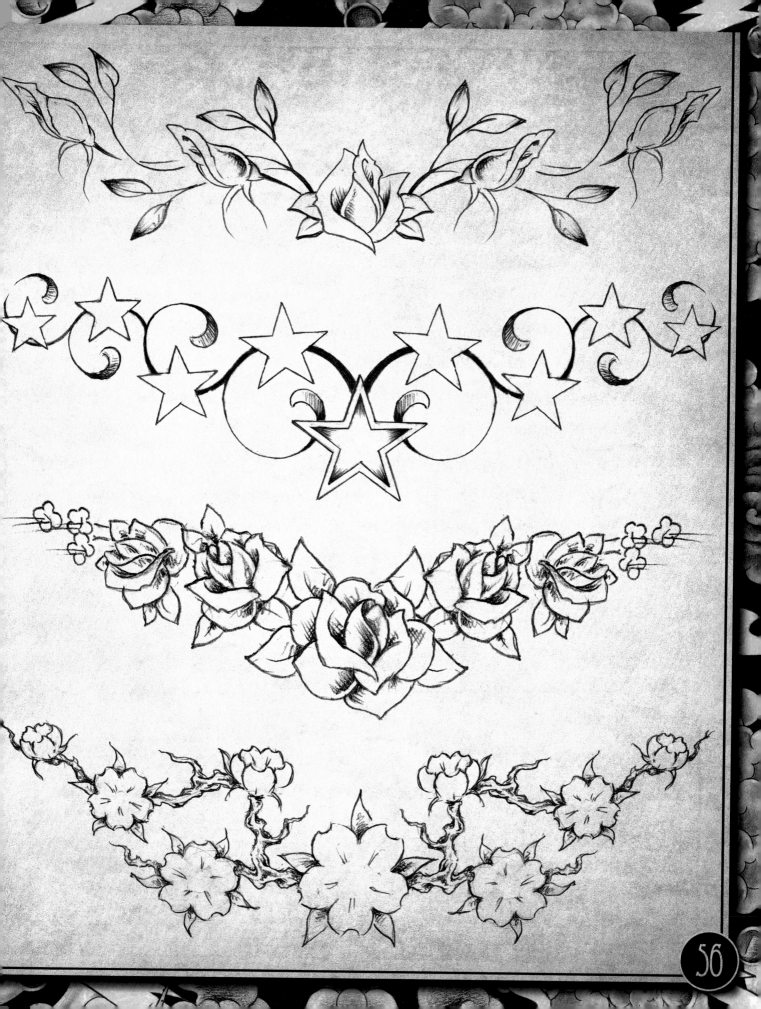

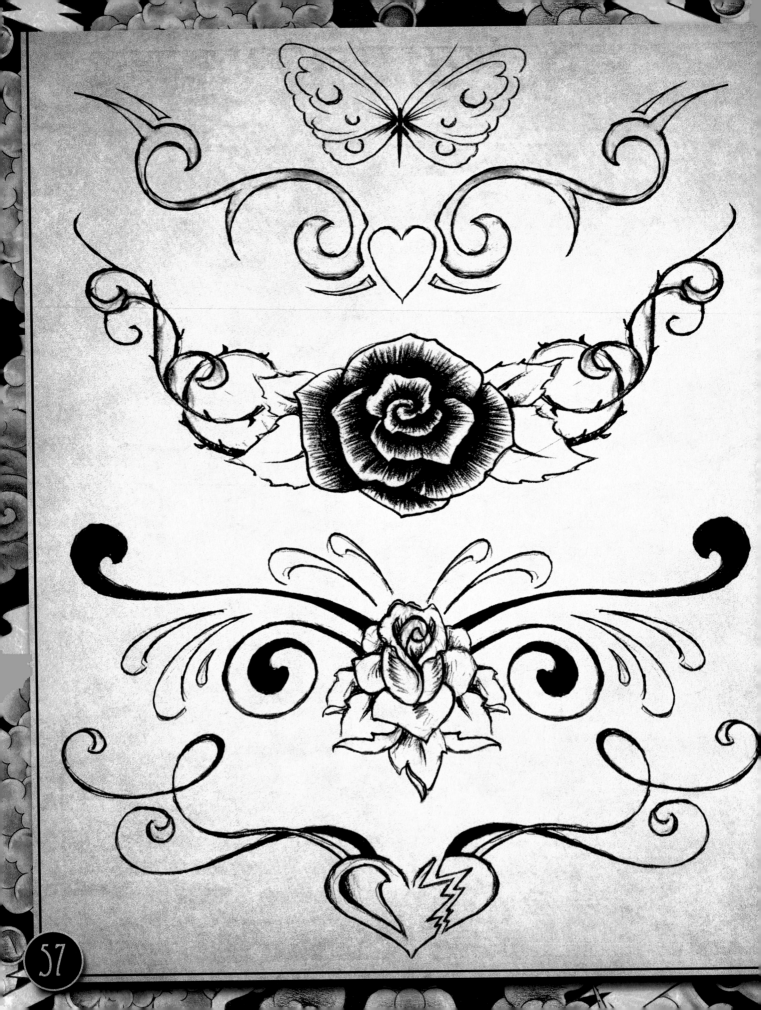

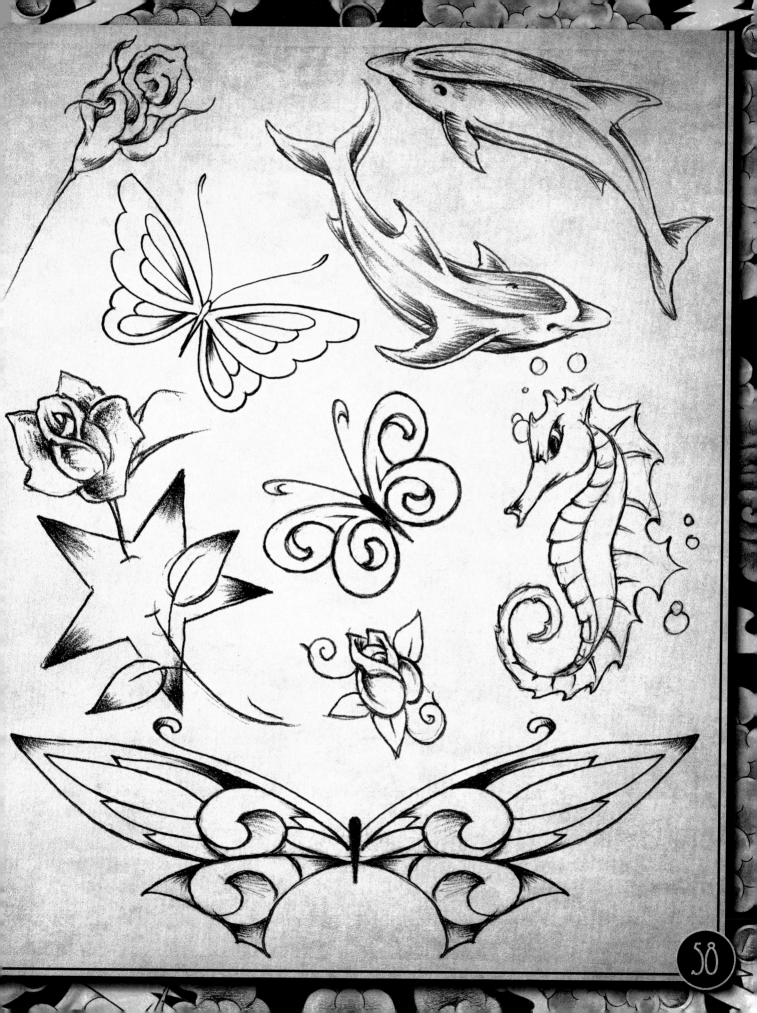

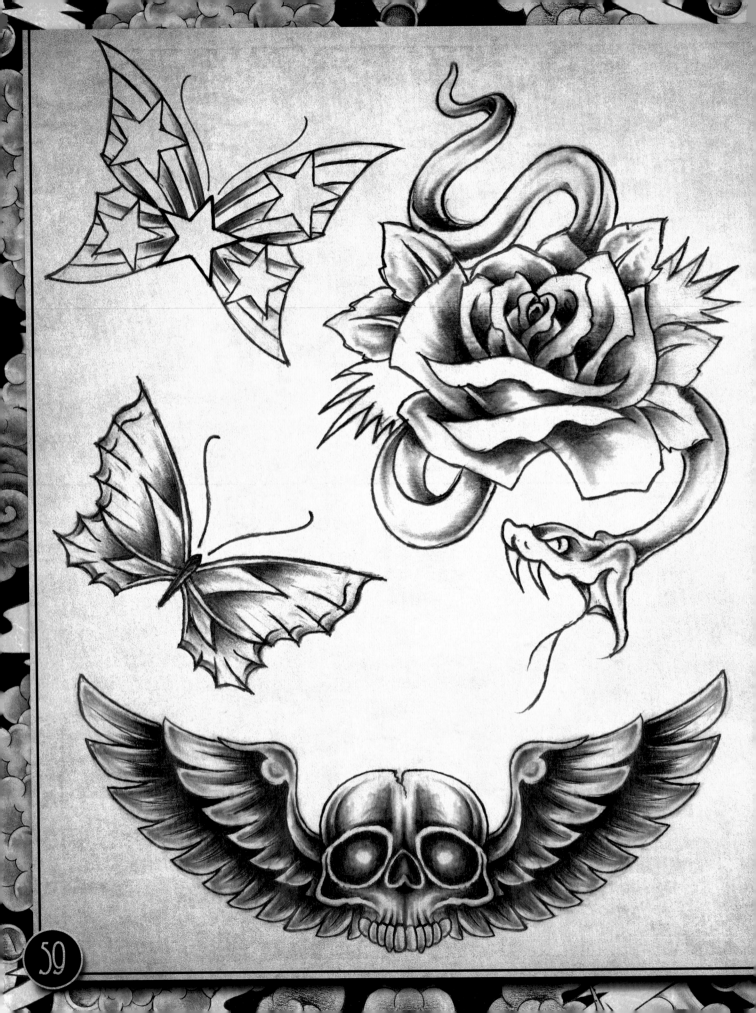

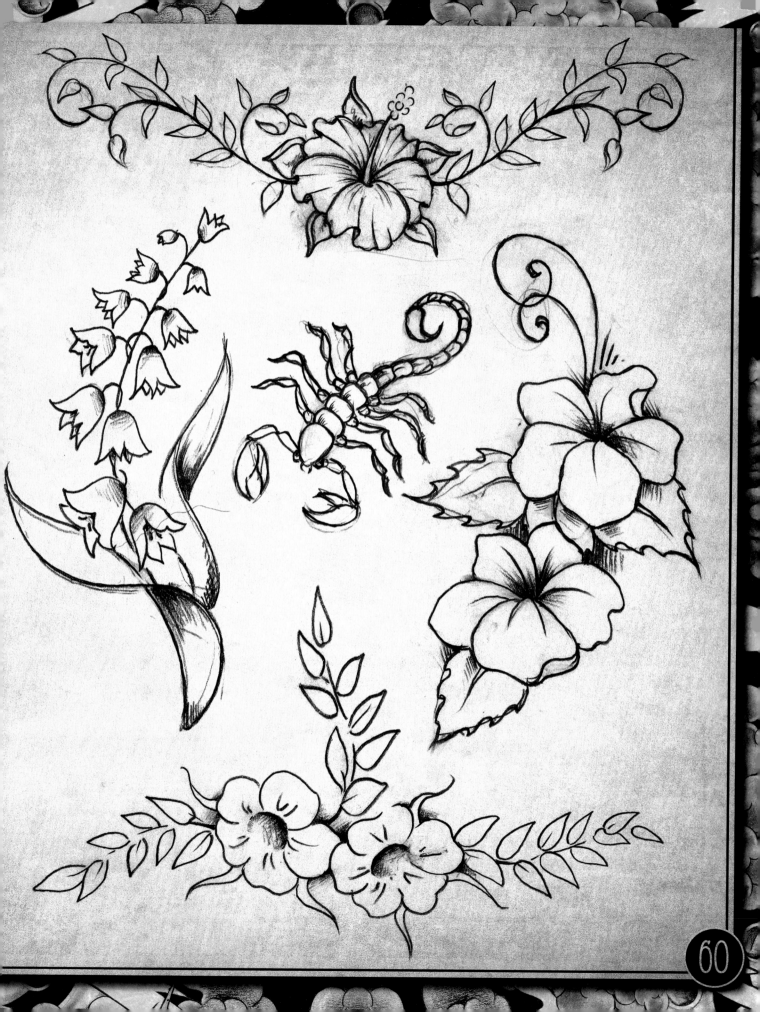

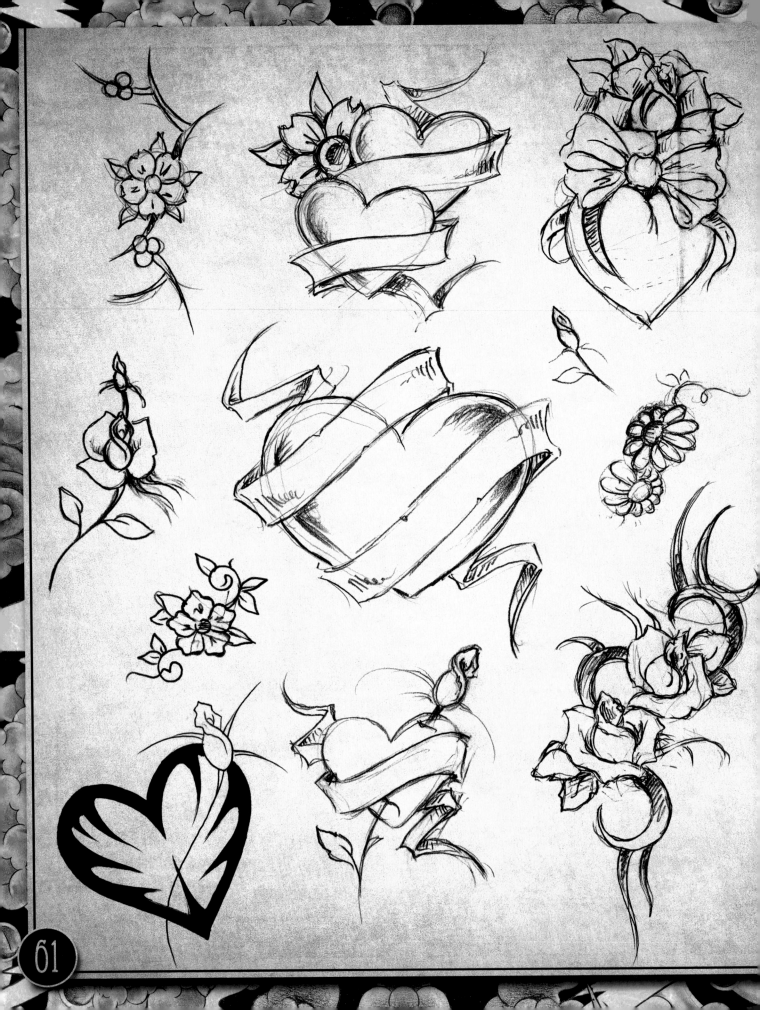

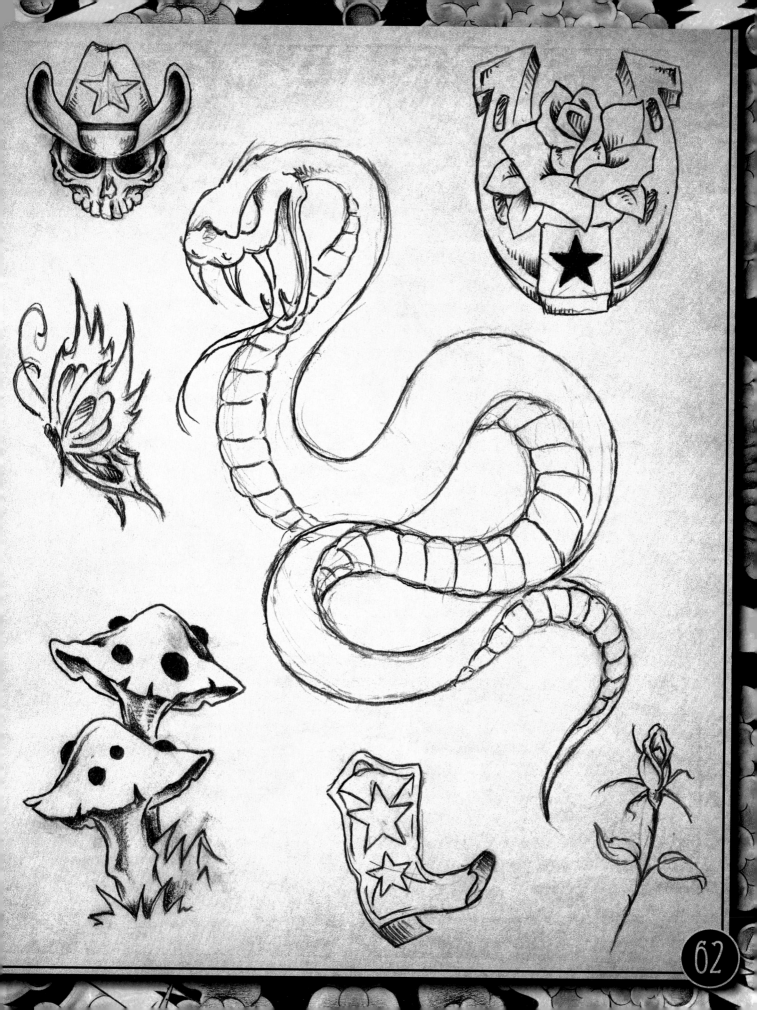

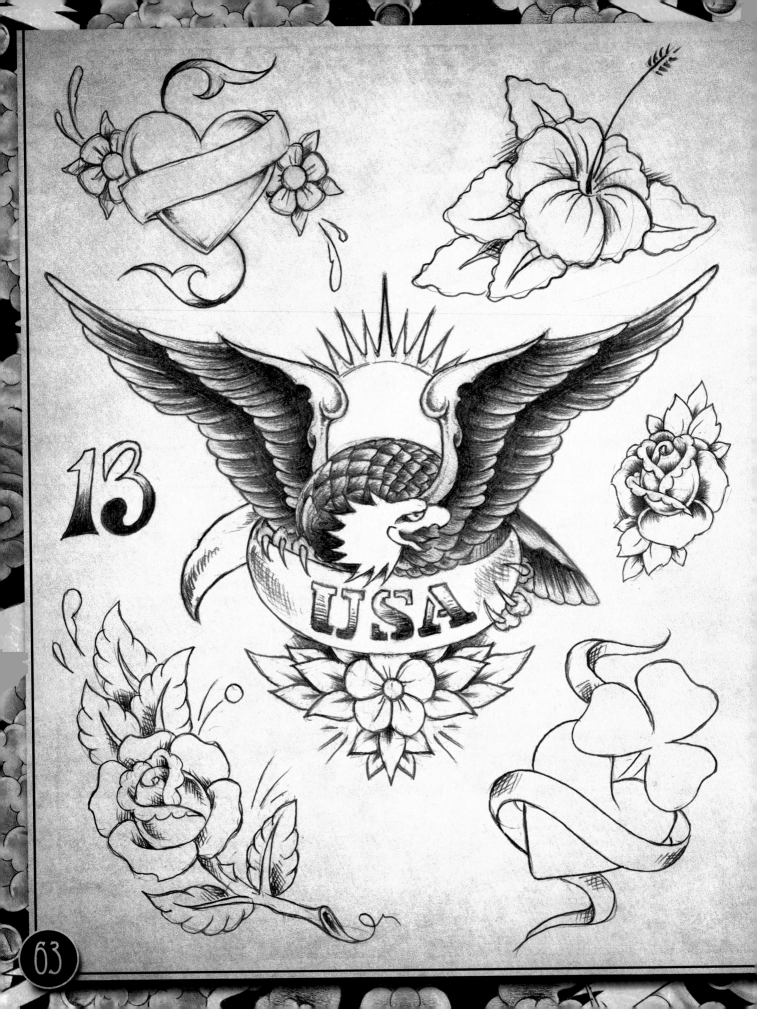

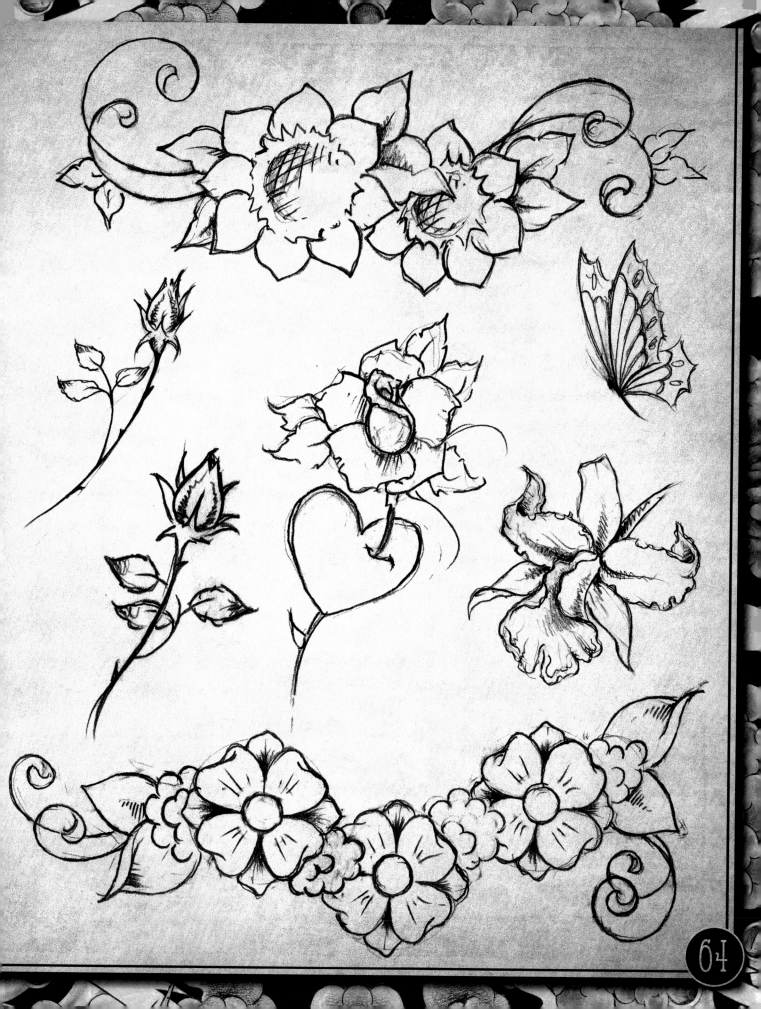

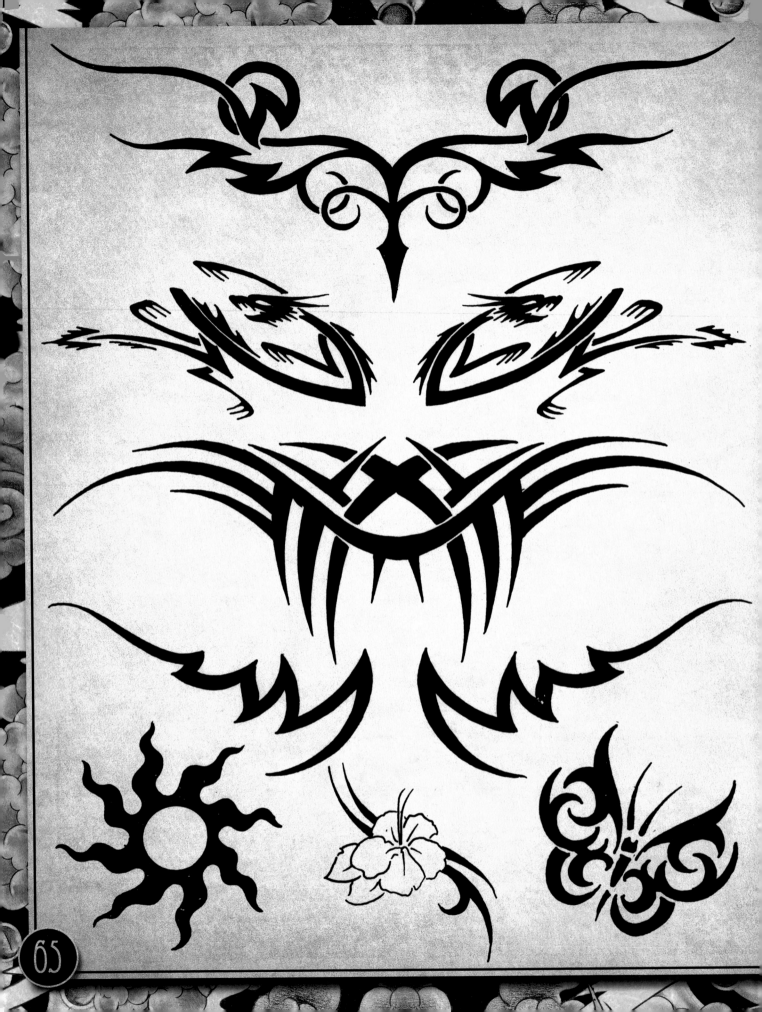

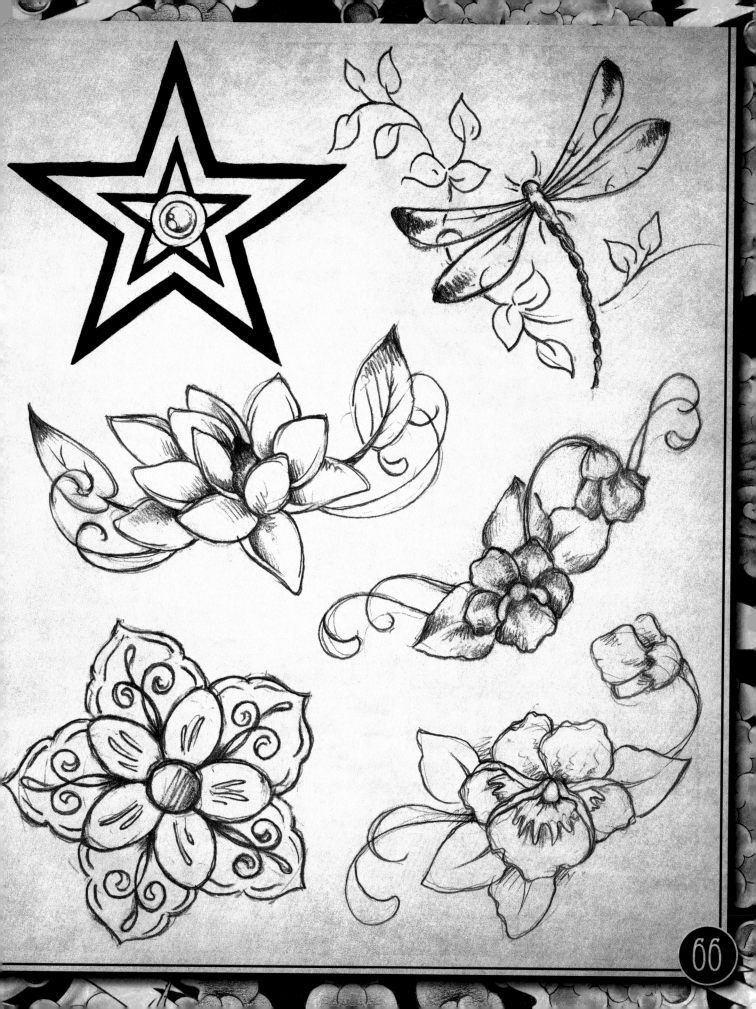

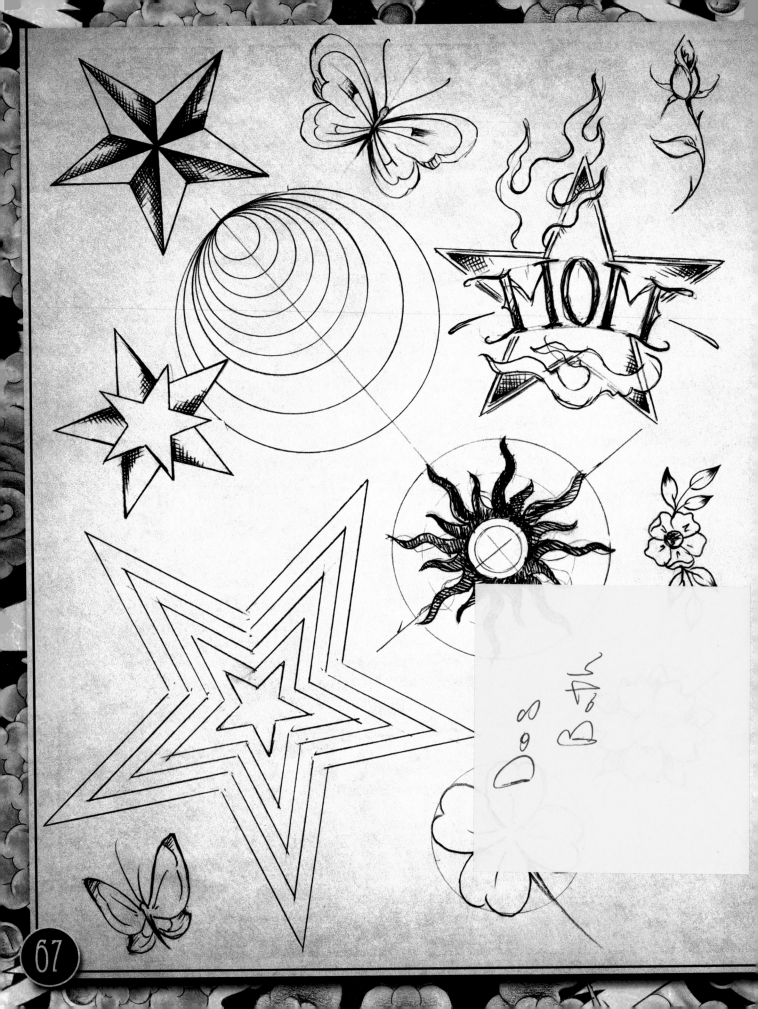

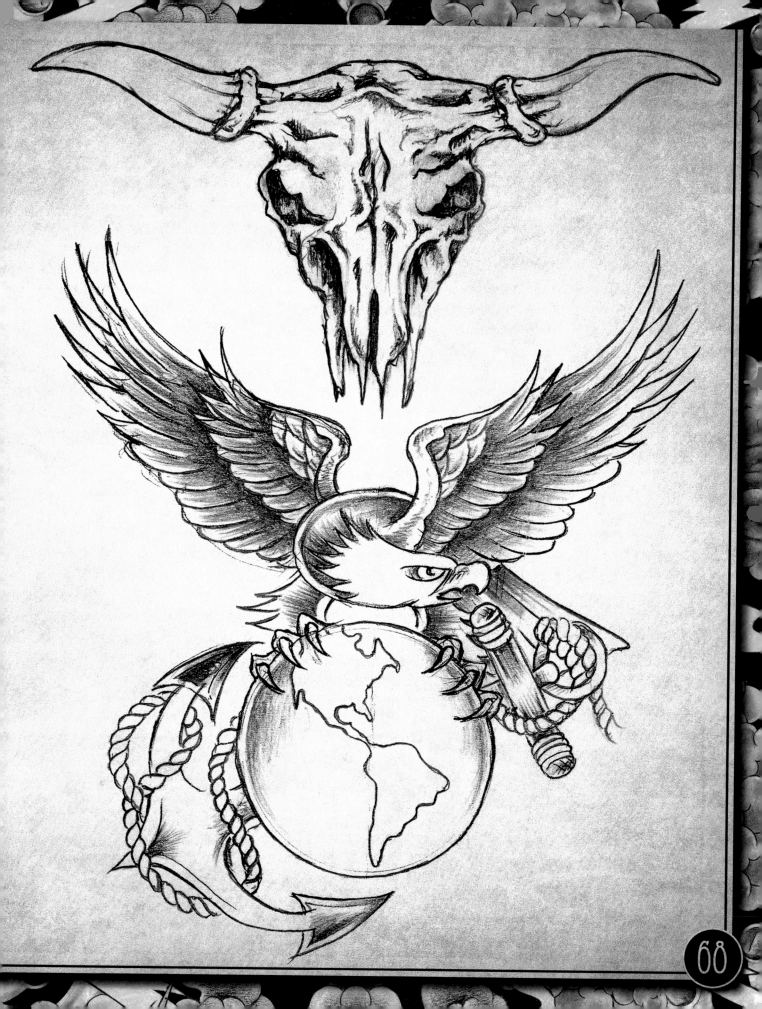

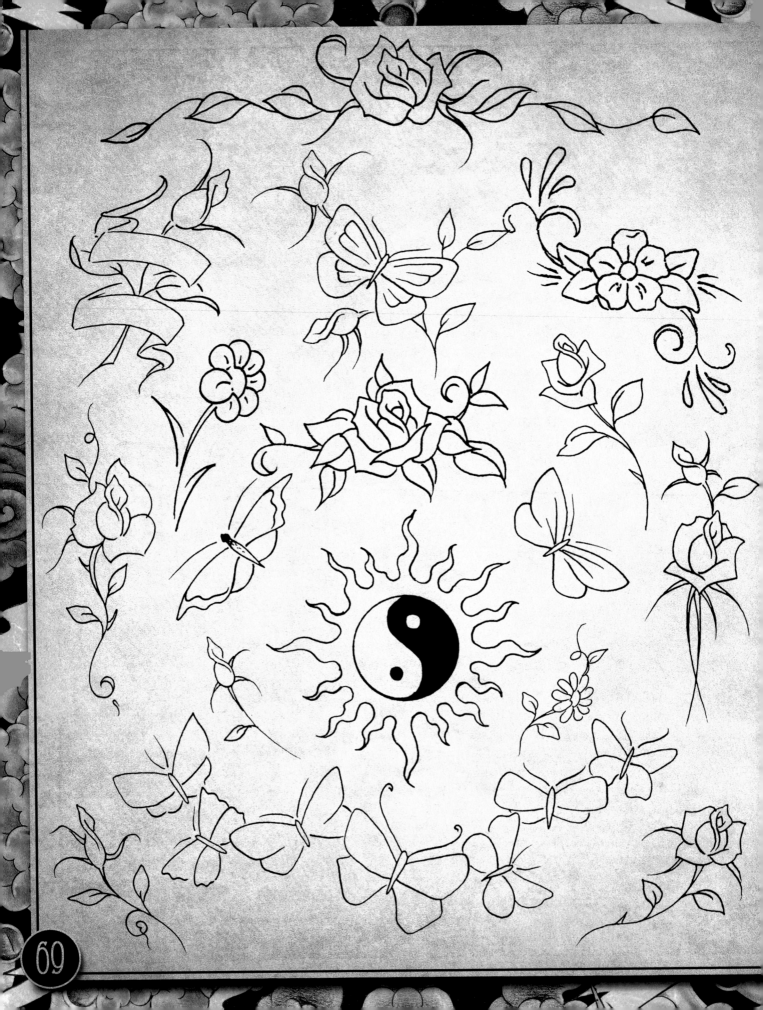

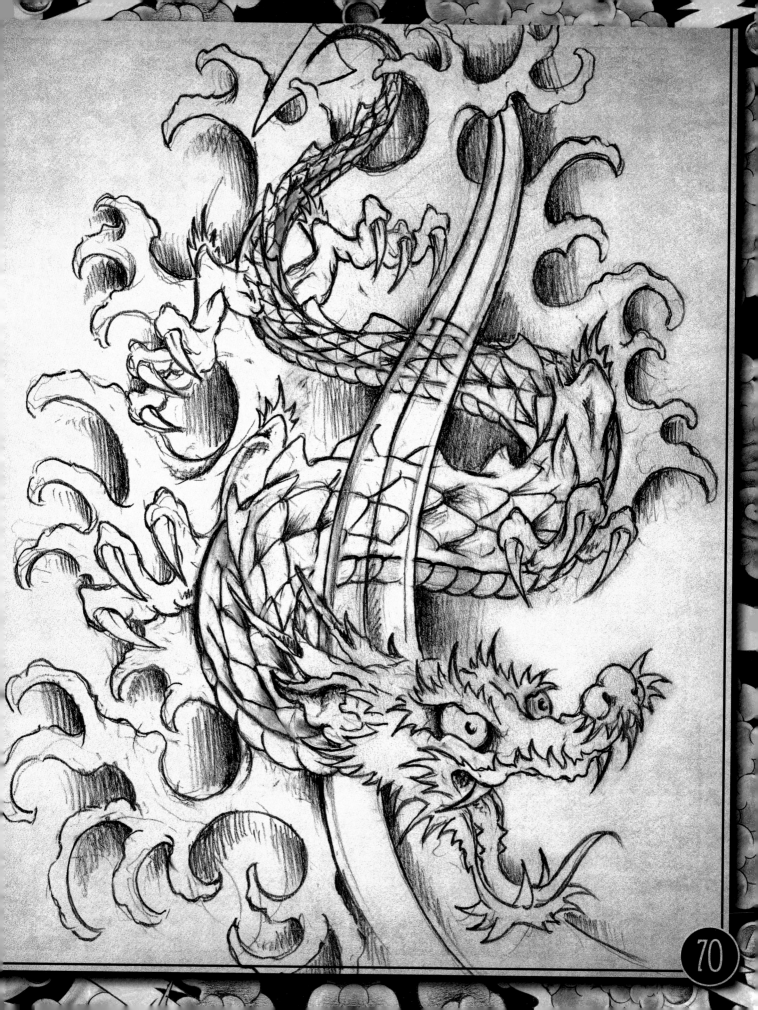

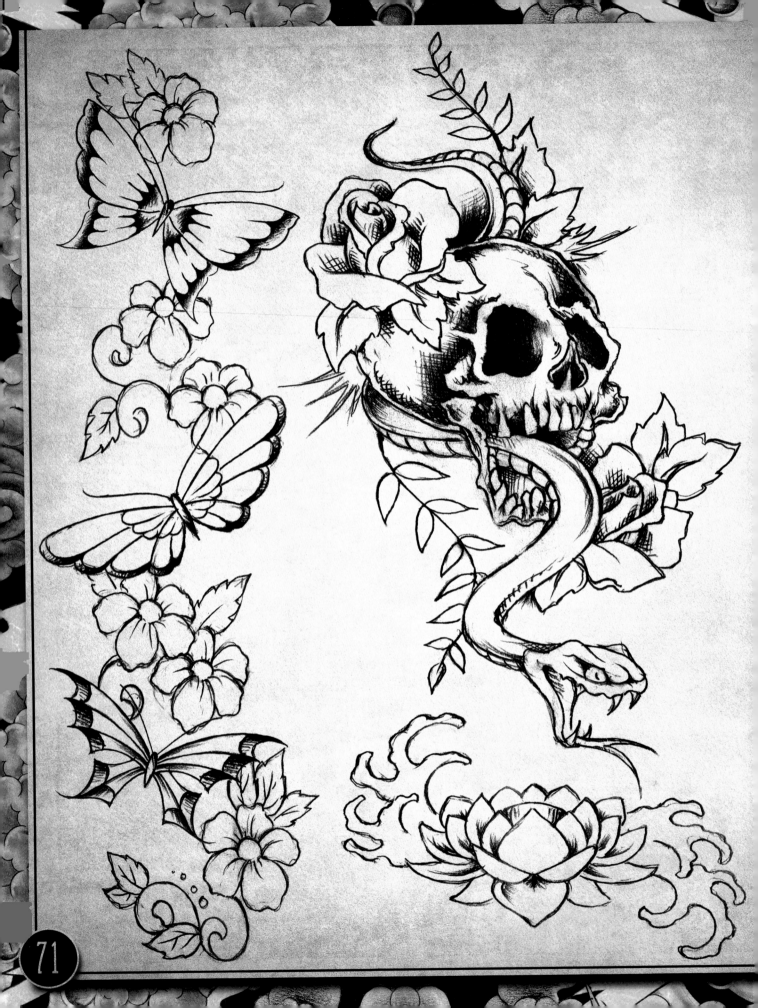

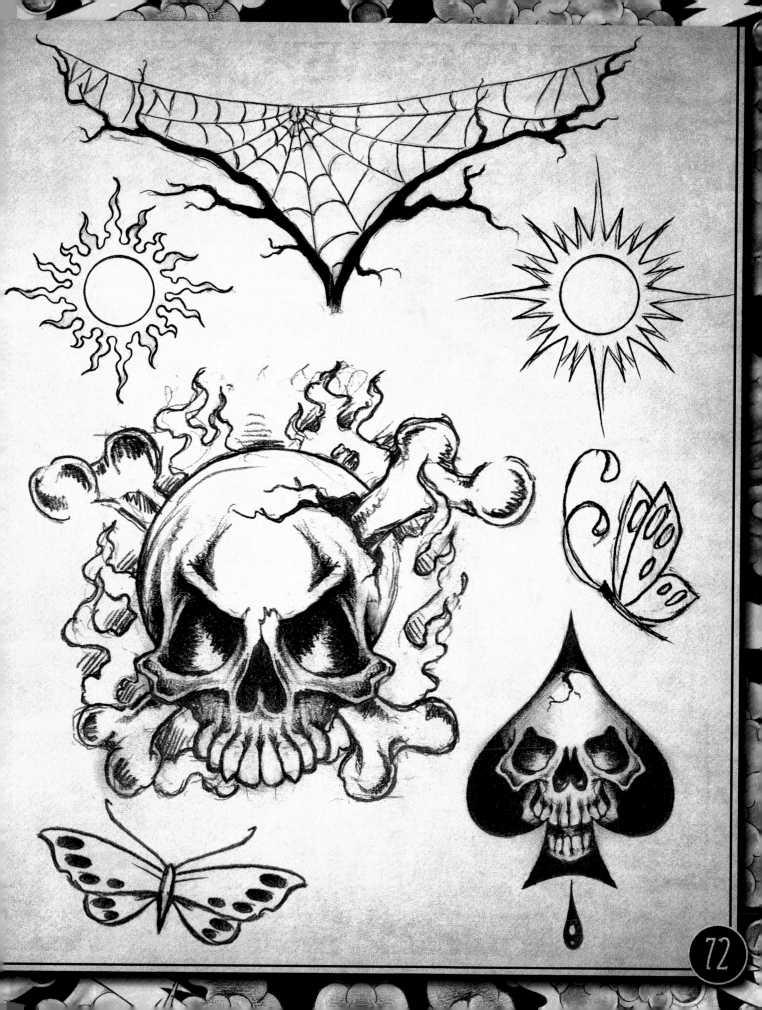

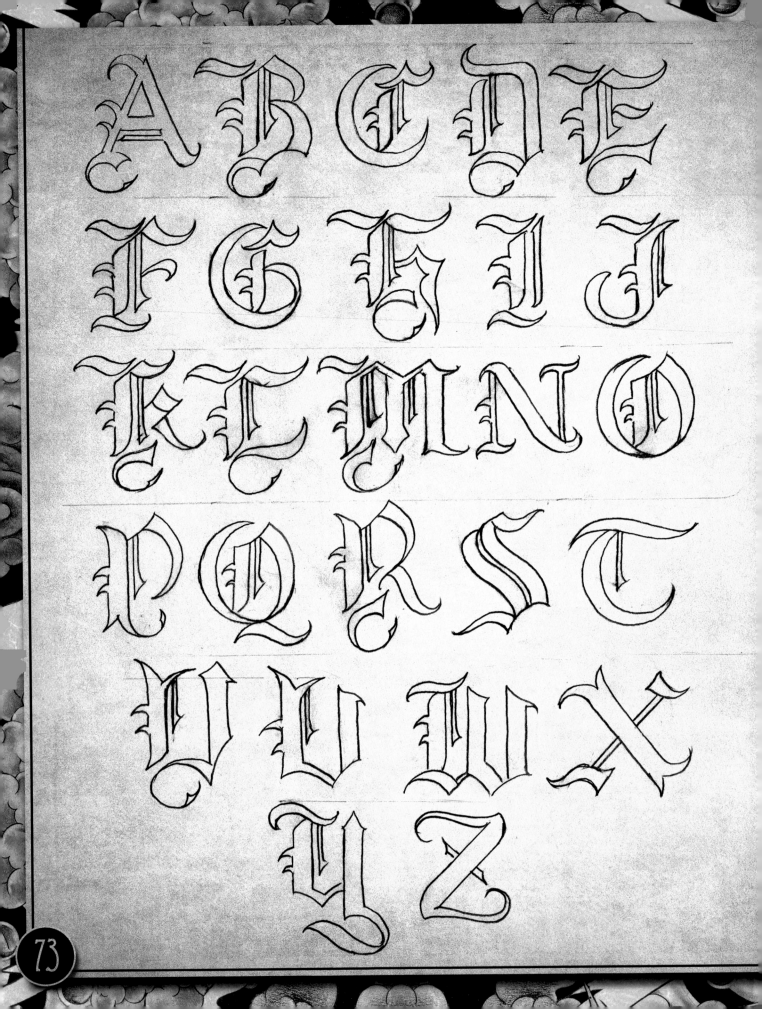

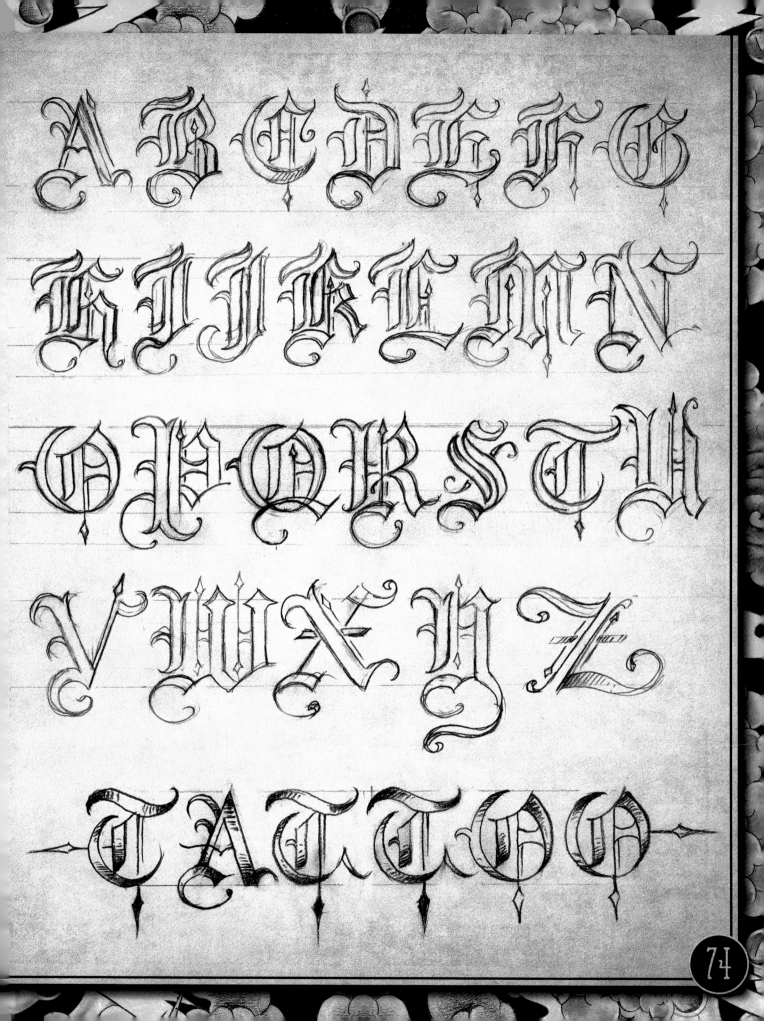

A B C D E F G

H I J K L M N

O P Q R S T U

V W X Y Z

TATTOO

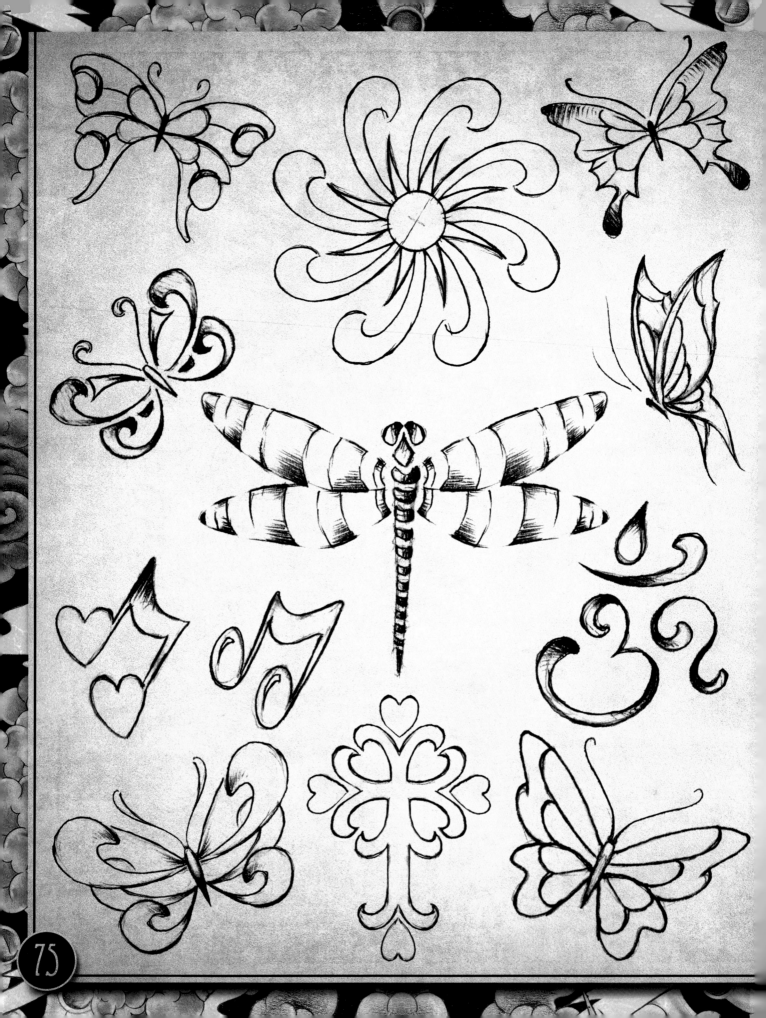

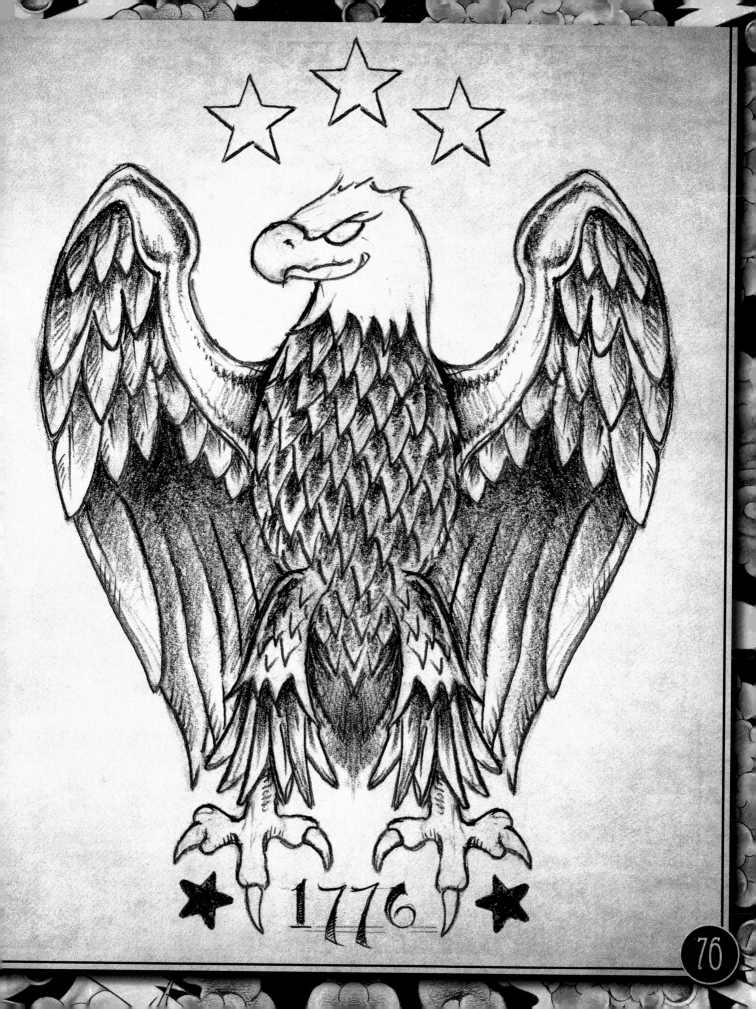

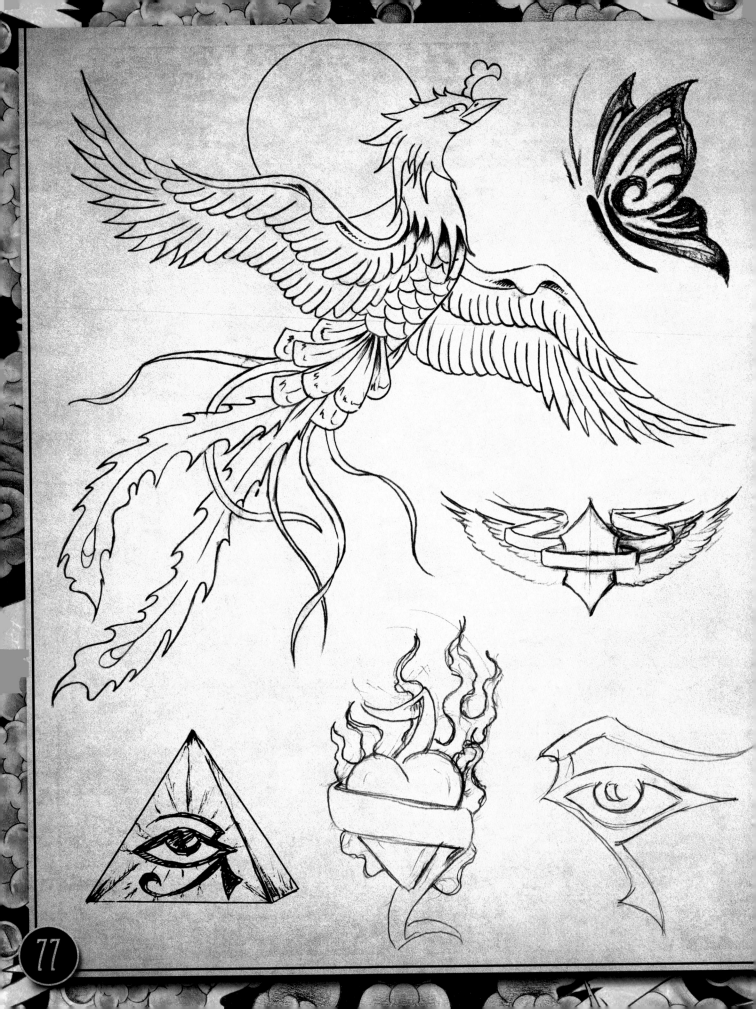

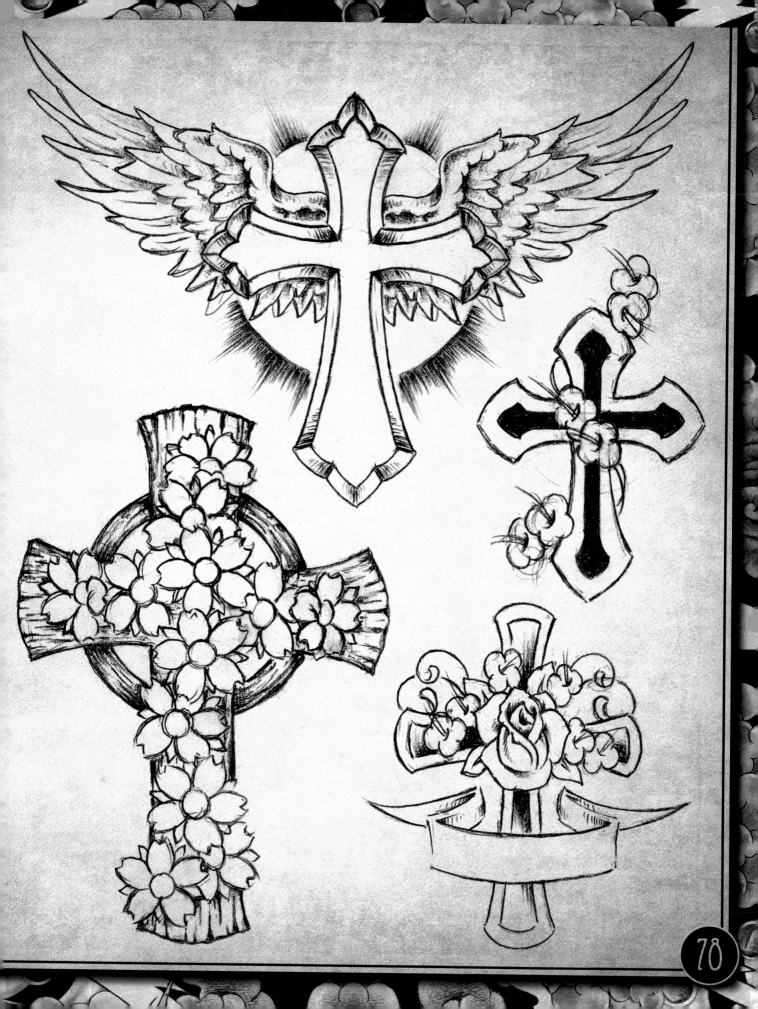

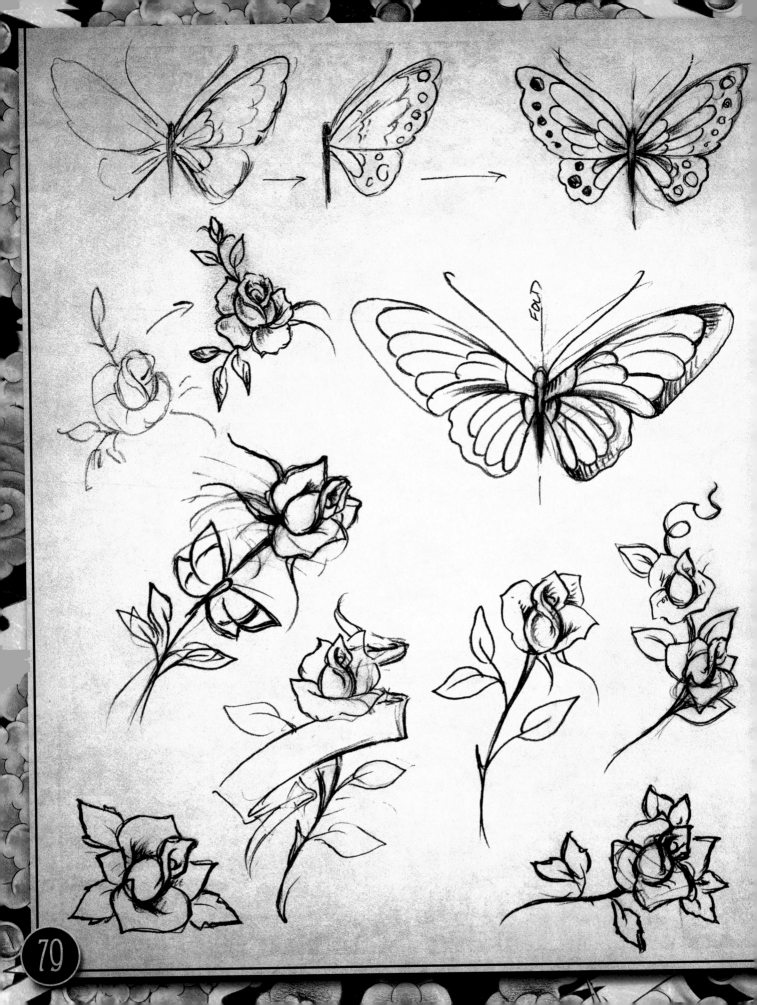

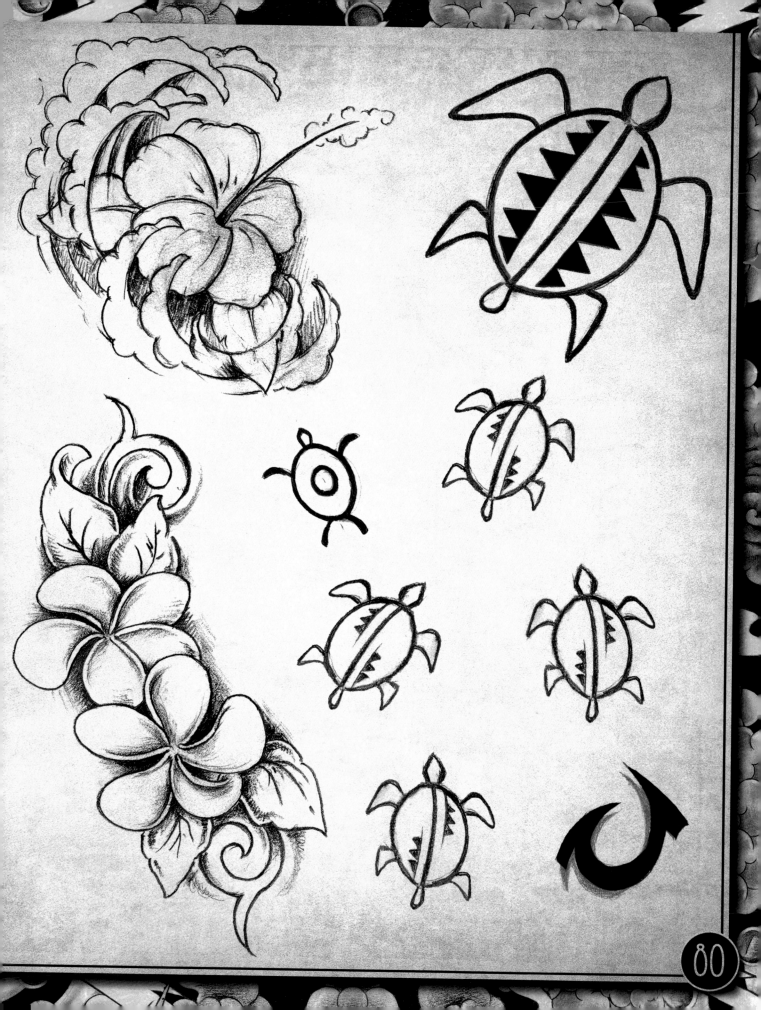

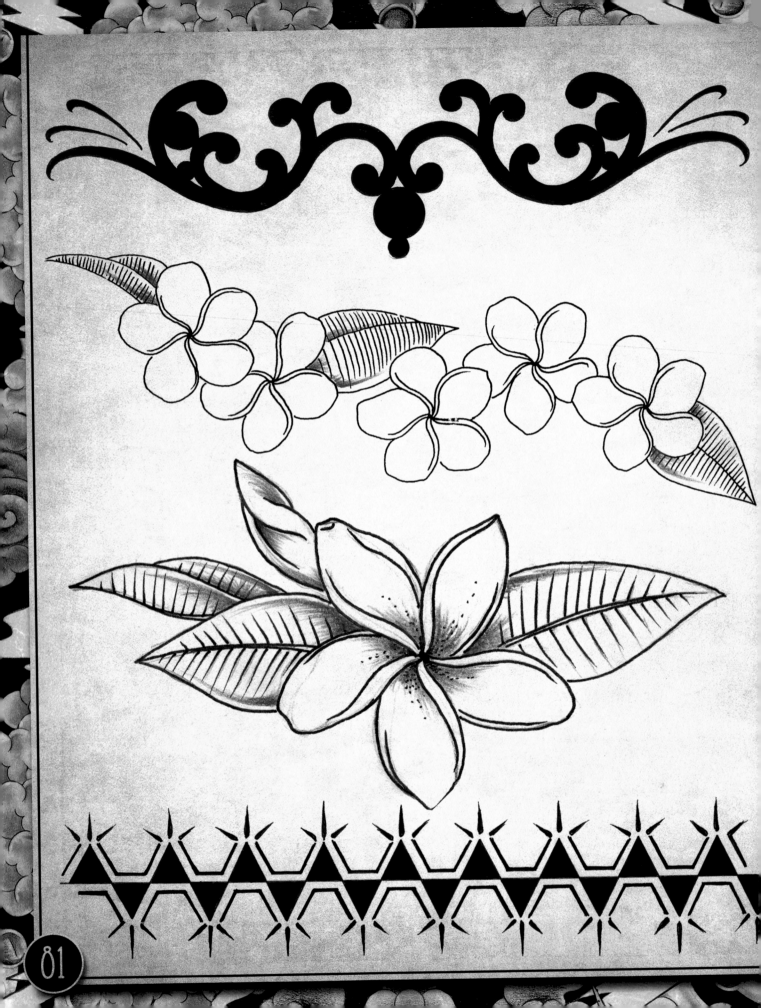

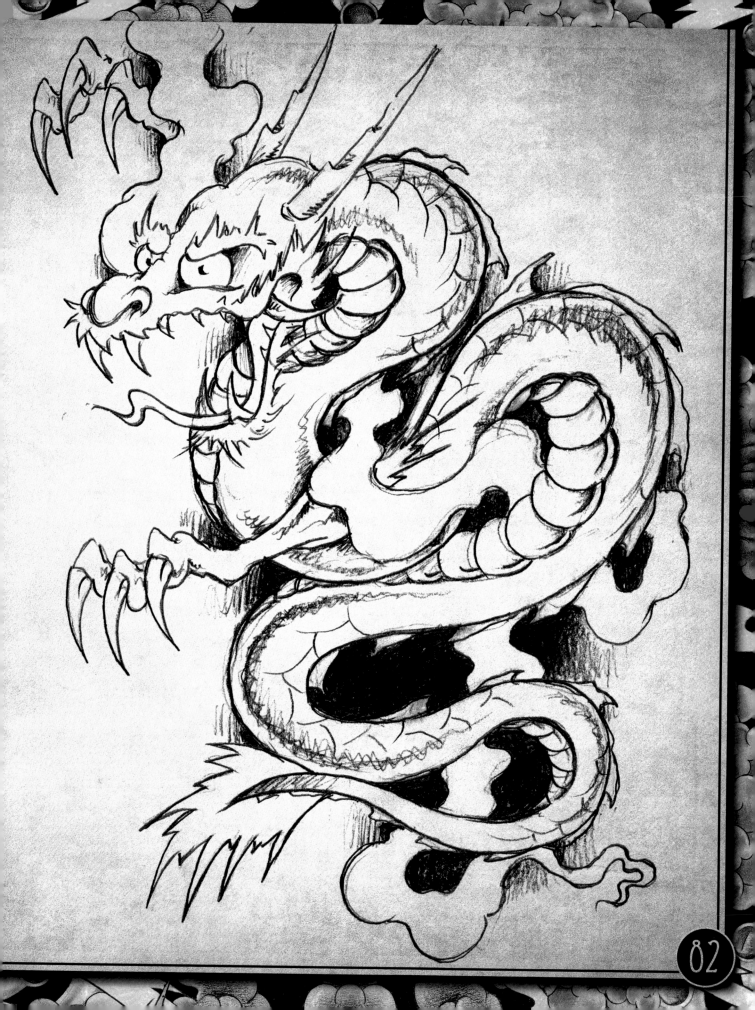

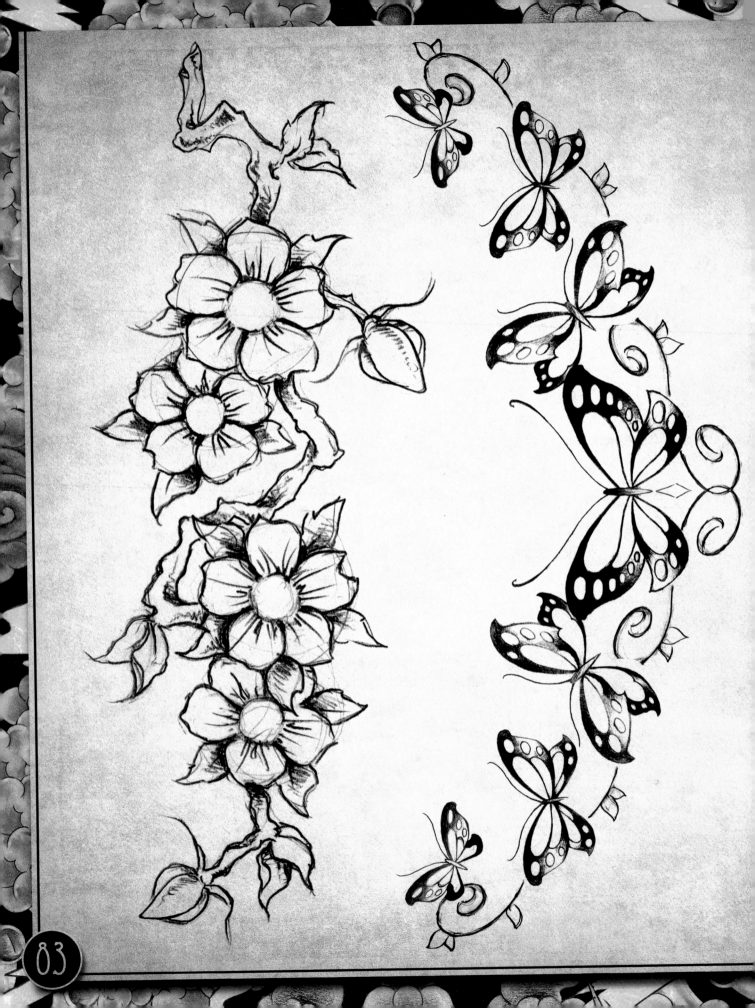

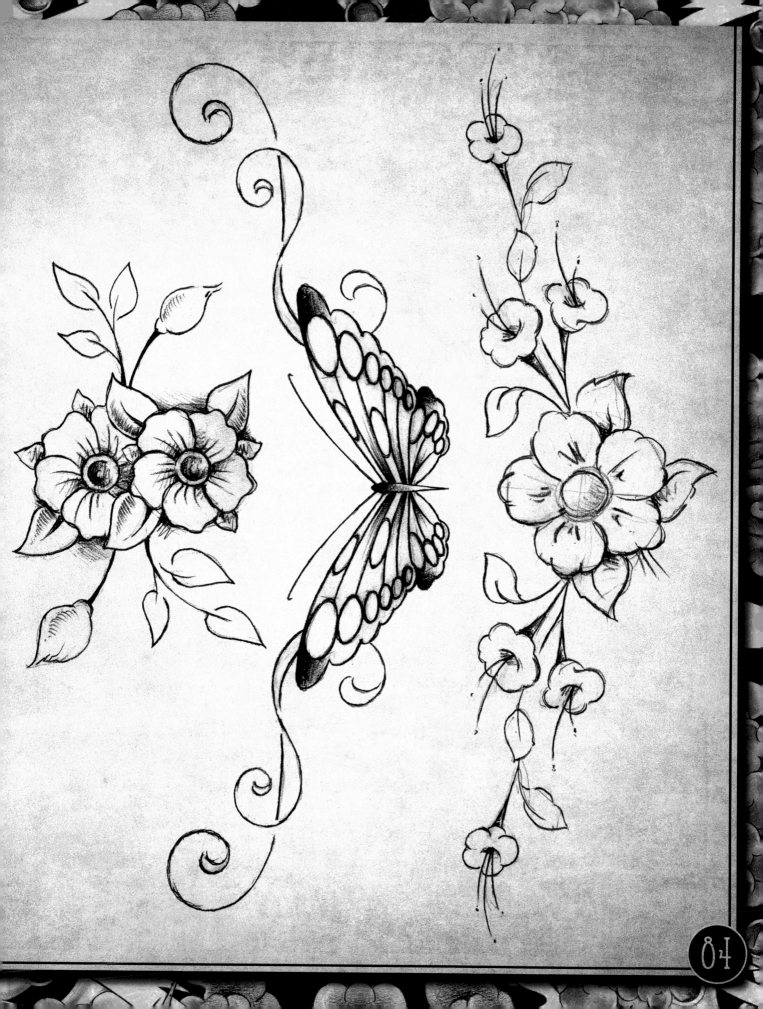

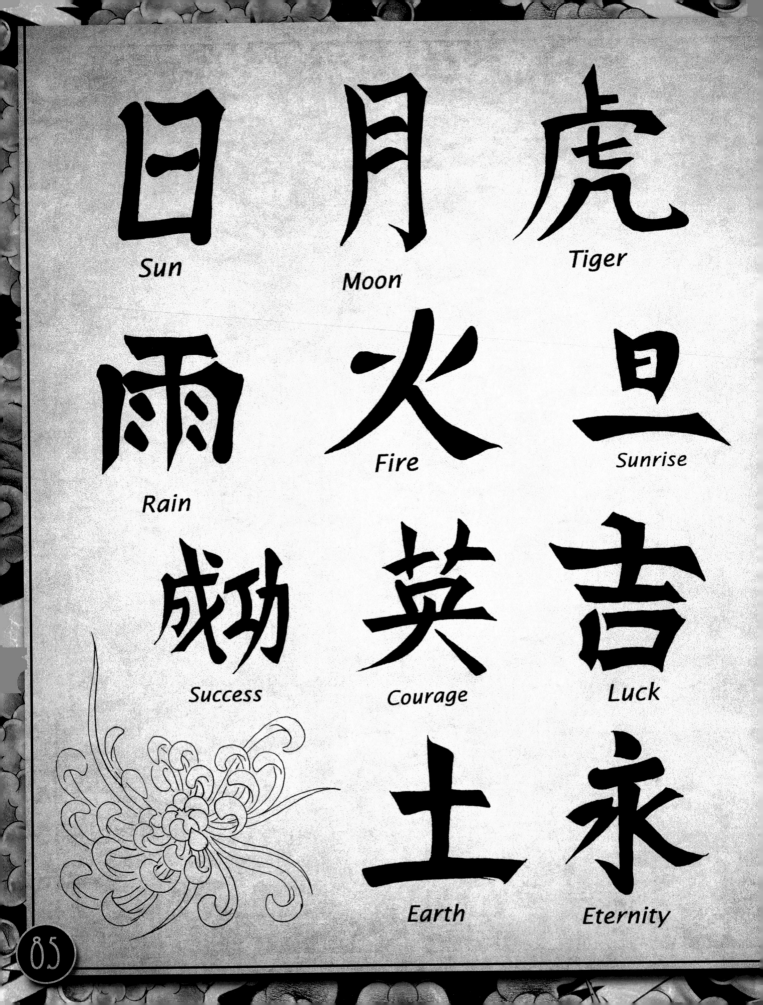

日 **Sun**

月 **Moon**

虎 **Tiger**

雨 **Rain**

火 **Fire**

旦 **Sunrise**

成功 **Success**

英 **Courage**

吉 **Luck**

土 **Earth**

永 **Eternity**

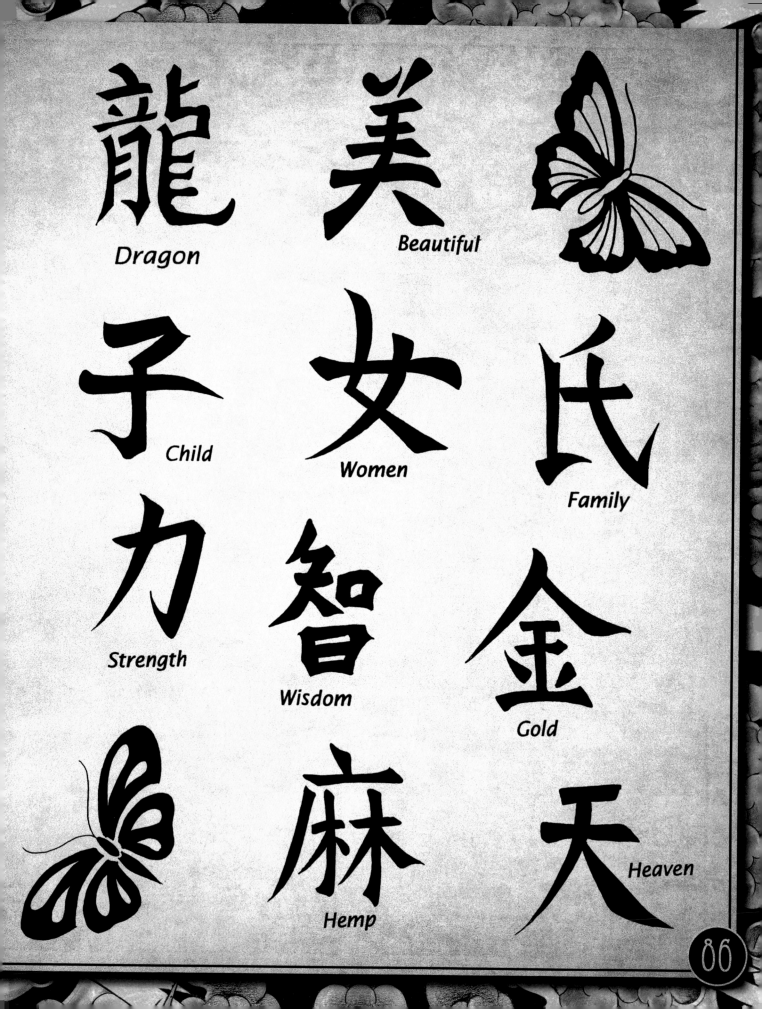

龍
Dragon

美
Beautiful

子
Child

女
Women

氏
Family

力
Strength

智
Wisdom

金
Gold

麻
Hemp

天
Heaven

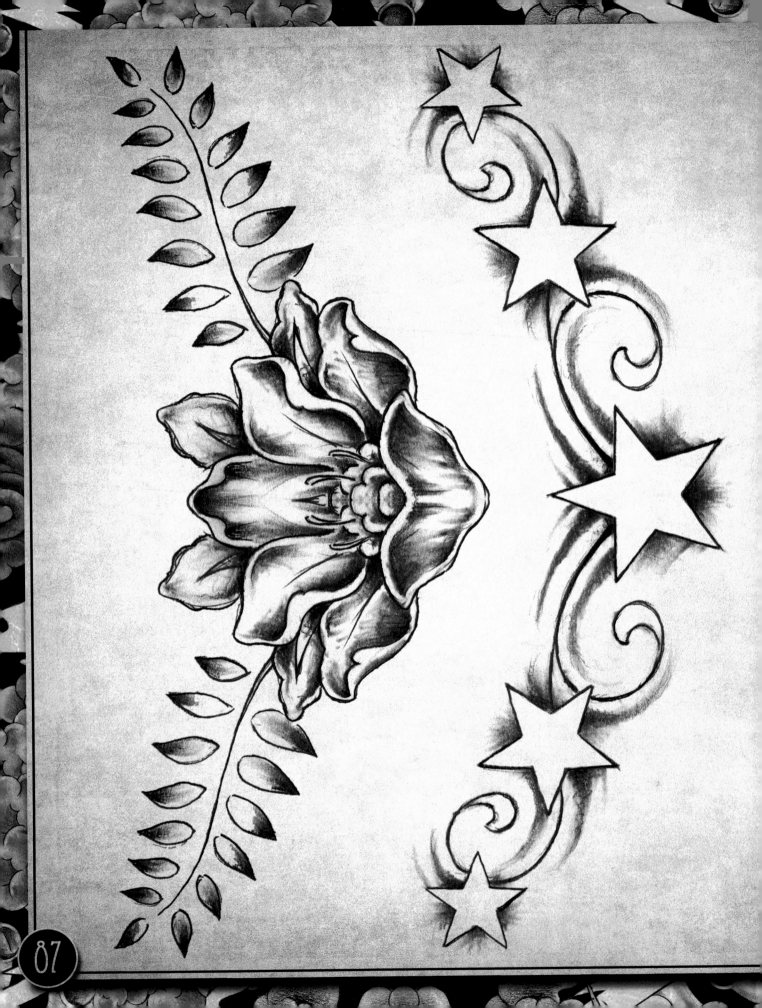

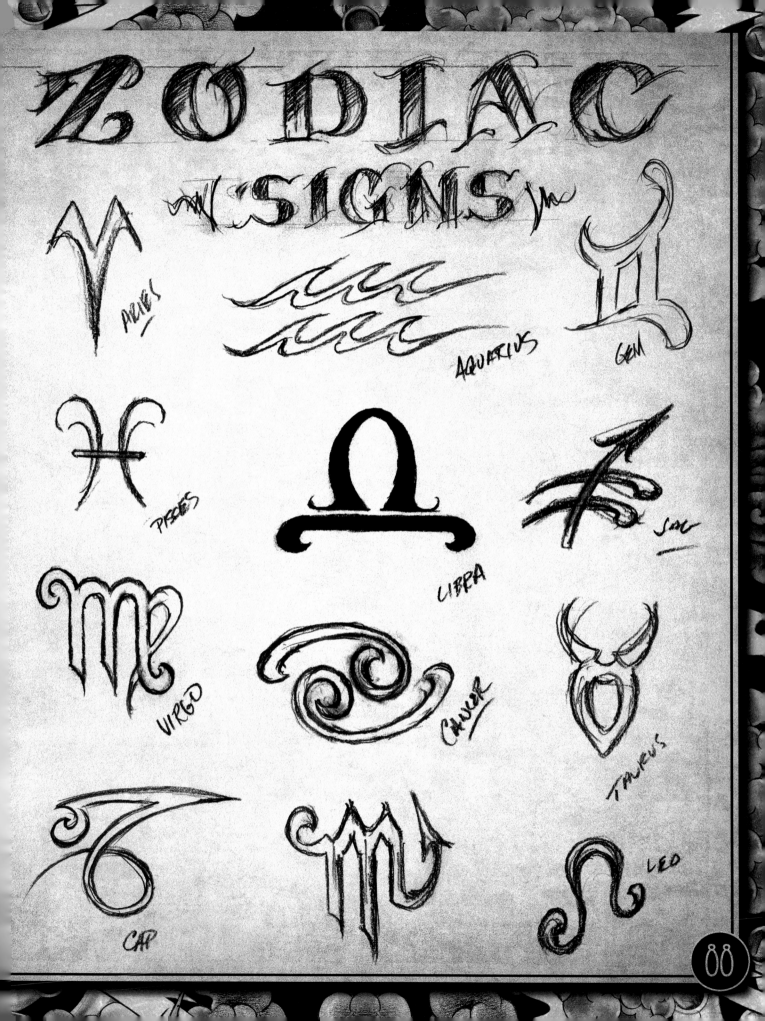

ZODIAC

SIGNS

ARIES

AQUARIUS

GEM

PISCES

LIBRA

SAG

VIRGO

CANCER

TAURUS

CAP

SCORPIO

LEO

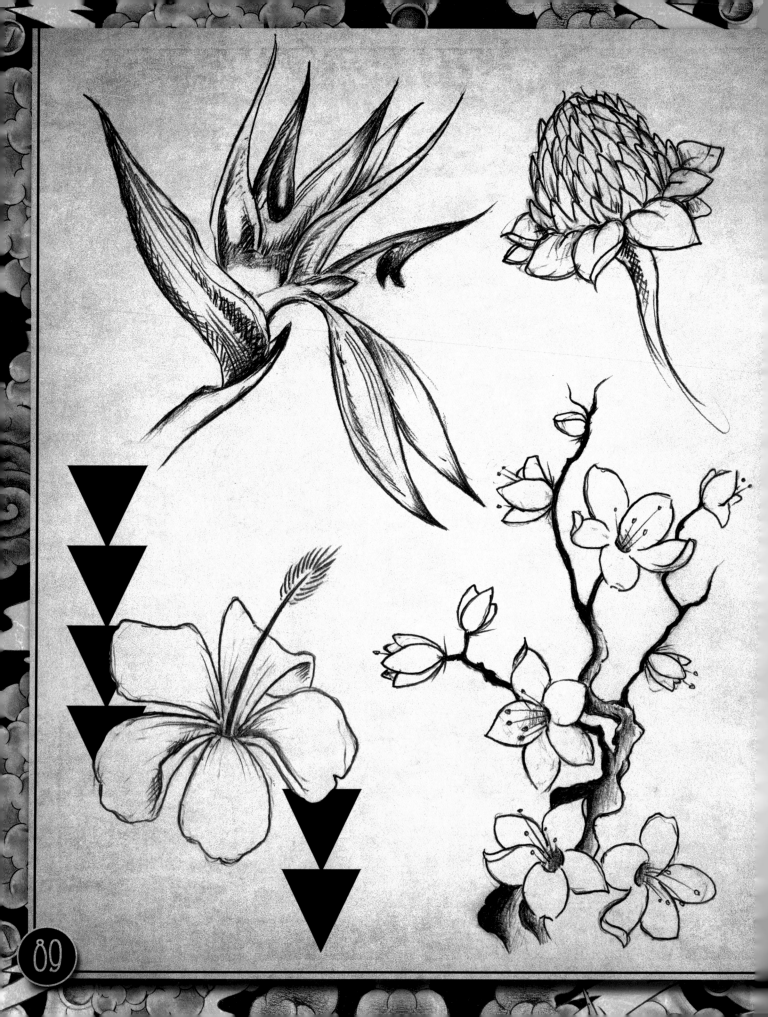

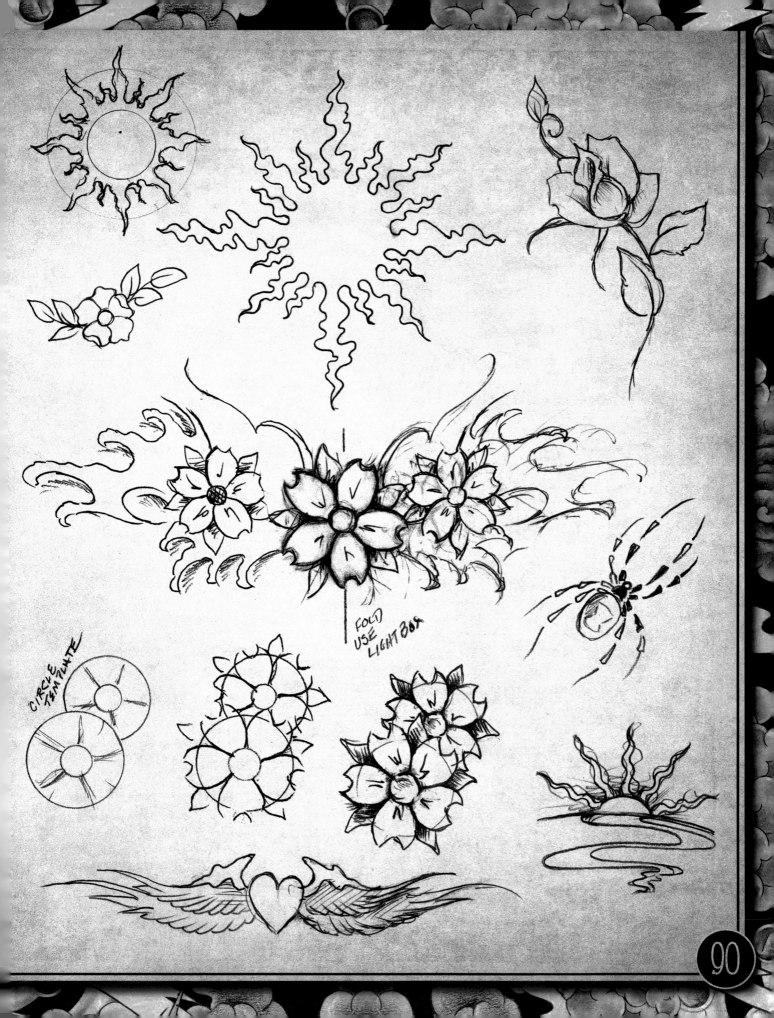

FOLD
USE
LIGHT BOX

CIRCLE
TEMPLATE

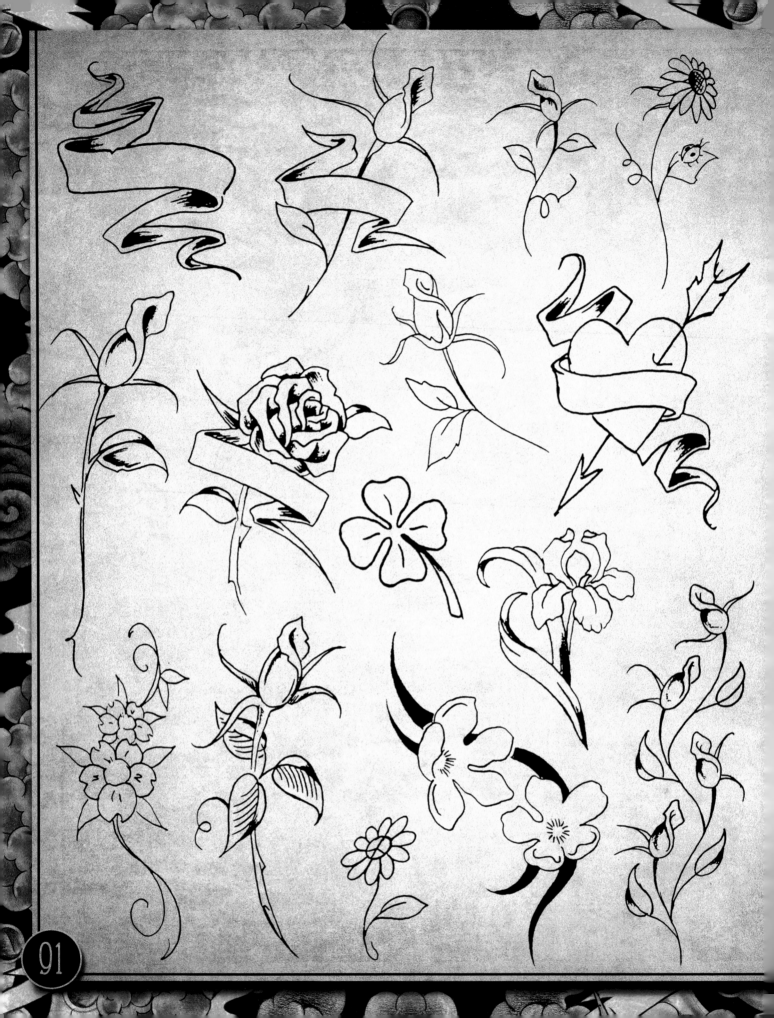

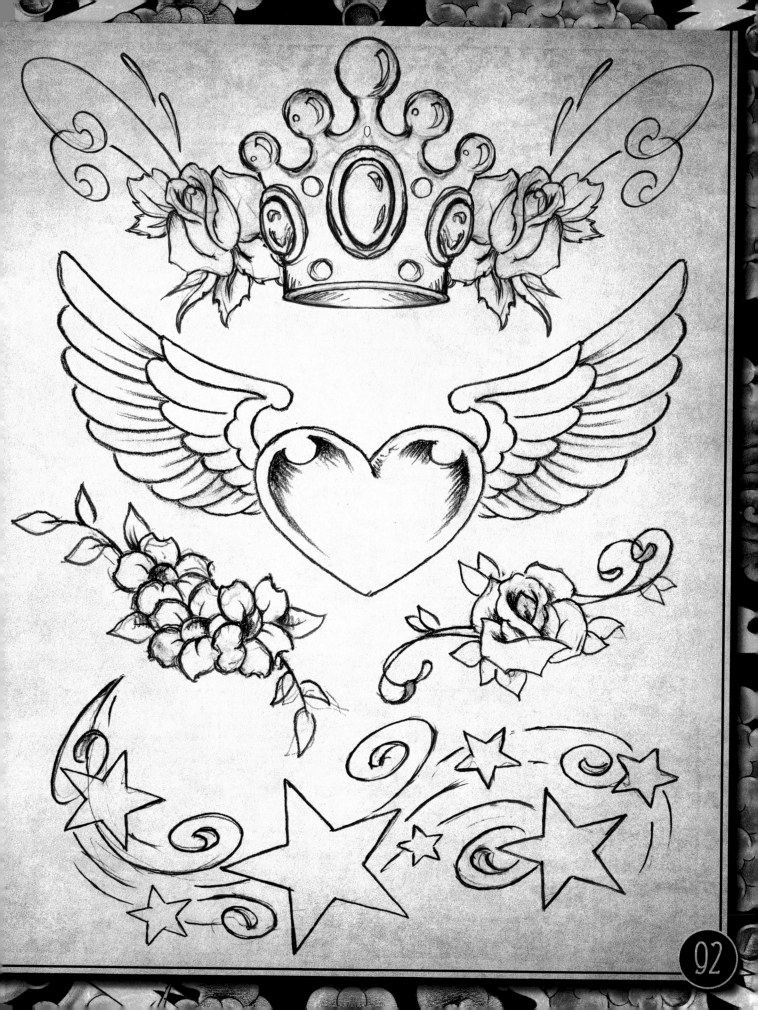

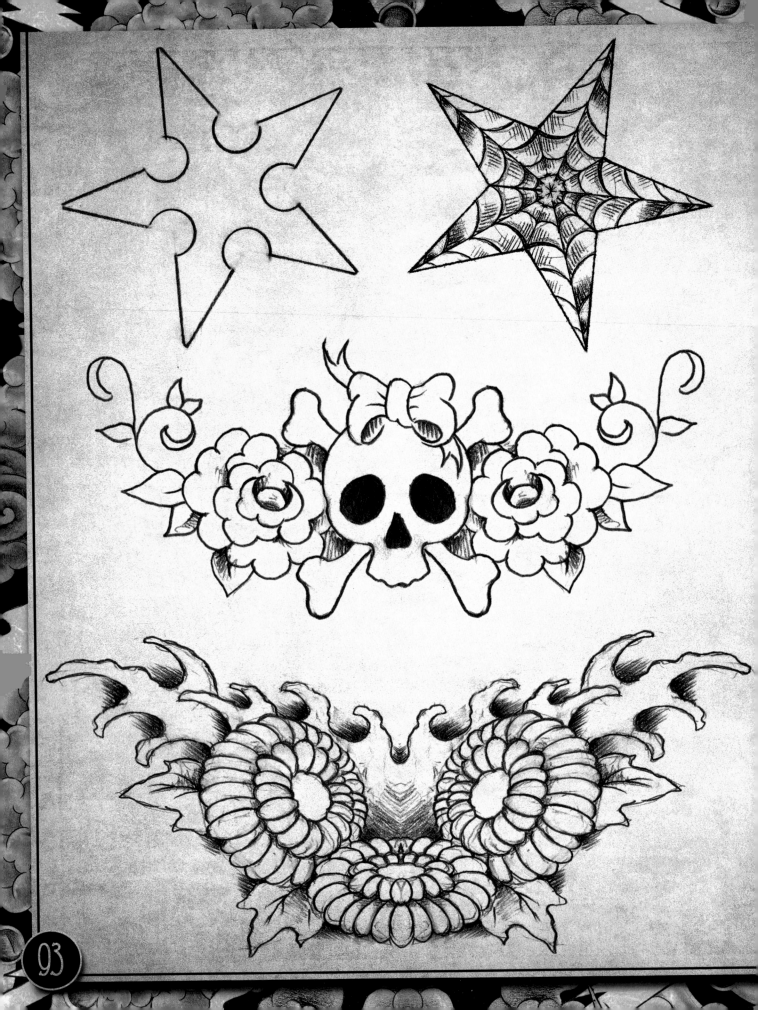

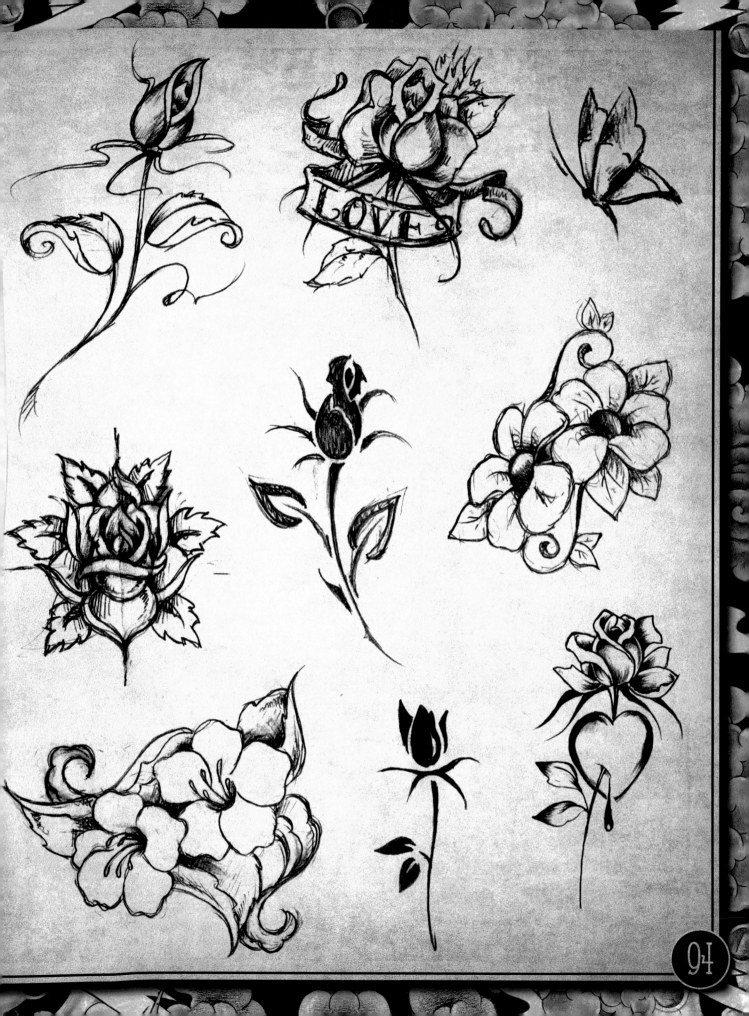

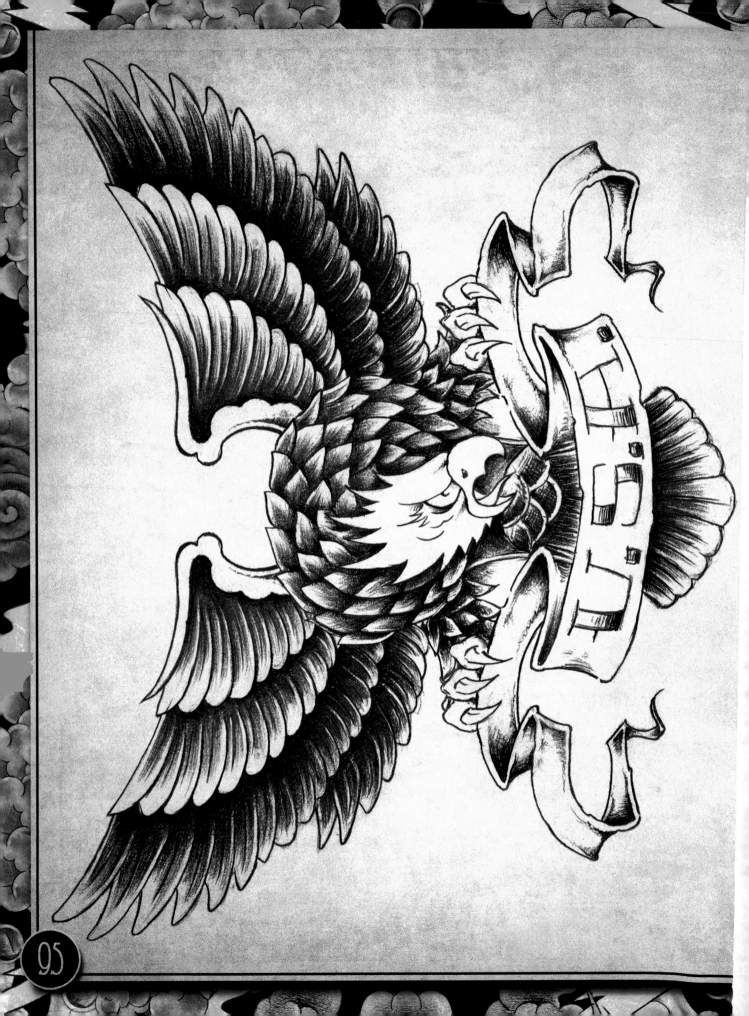